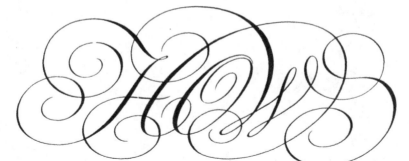

TOMMY THOMPSON
SCRIPT
LETTERING
FOR ARTISTS

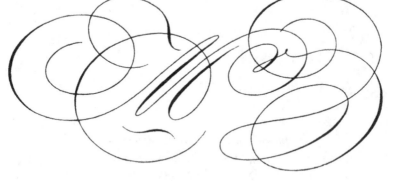

DOVER PUBLICATIONS, INC., NEW YORK

This Dover edition, first published in 1965, is an unabridged and corrected republication of the revised (1955) edition of the work first published by Studio Publications in 1939 under the title *The Script Letter: Its Form, Construction and Application.*

International Standard Book Number

ISBN-13: 978-0-486-21311-8
ISBN-10: 0-486-21311-0

Manufactured in the United States by LSC Communications
21311011 2016
www.doverpublications.com

ACKNOWLEDGMENT

*The author wishes to
express his appreciation for the
co-operation given him by the art directors
who have, first of all,
commissioned him to do much of the work herein and who,
in many cases, deserve much
of the credit for its finished form
by virtue of their intelligent direction and
beautiful preliminary roughs*

*Many thanks are especially extended to
Paul Smith for his contribution
on Advertising Layout,
and to Will Dwiggins for his
authoritative corrections.*

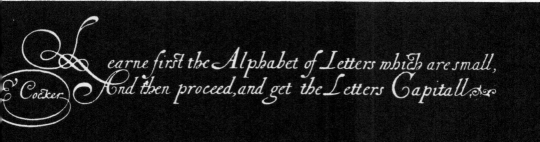

EDWARD COCKER, ART'S GLORY, 1659. *(New York Public Library)*

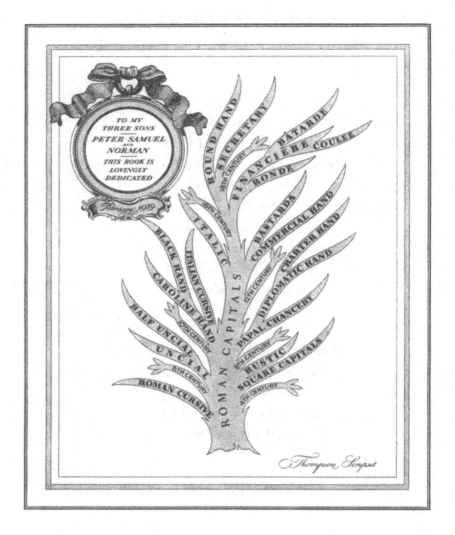

TO MY
THREE SONS
PETER·SAMUEL
AND
NORMAN
THIS BOOK IS
LOVINGLY
DEDICATED

ROUND HAND
18TH CENTURY
SECRETARY
BATARDE
FINANCIERE COULEE
RONDE
ITALIC
16TH CENTURY
BASTARDA
COMMERCIAL HAND
CHARTER HAND
ITALIAN CURSIVE
DIPLOMATIC HAND
15TH CENTURY
BLACK HAND
CAROLINE HAND
PAPAL CHANCERY
HALF UNCIAL
9TH CENTURY
RUSTIC
UNCIAL
8TH CENTURY
SQUARE CAPITALS
6TH CENTURY
ROMAN CURSIVE
4TH CENTURY
ROMAN CAPITALS

Thompson, Scripsit

The Lineage of the Script Letter traced

THE ROMAN CAPITALS

6

P R E F A C E

AN attempt from the beginning of writing to show all the changes that have occurred in the growth of the script letter, step by step from pre-alphabet times to the present day, would be too great an undertaking in a book of this kind. It is desirable, of course, that the student acquaint himself with the story of the development of the alphabet. Many authoritative historians and archaeologists have prepared fine works on this subject. A general reading of these I recommend.

This book is designed as a textbook to help the working student to a fuller appreciation of the best script forms in use to-day. In my search for help in learning to letter, I found an abundance of books and advice on the subject of lettering, mostly presented by men who did not work at it. I present here only that material which I believe will be helpful.

My information has come from many sources. I am as grateful to the many helps unmentioned as to those acknowledged.

I RAETOR EX · H · L · QVAERETIΓA DICAREIS
AMPLIVS BIS·IN·VNO· VBI·DVAE TA RTES
D SINE MALO · ΓEQVLAT VM · FIAT· T R · QVEI

II VARIAEVENEREARTESLABOR
ROB ET DVRISSVRGENSIN R

III NONDABITURREGNISESIOLROHIBERELATINIS·
AIQVEINMOTAMANETFATISLAVINIACONIUNX·
AITRAHIAI·AIQ·MORASTANTISLICETADDIAEREBVS·

IV ANIIAOUERTIUNAMSENTENLIOLAMUERBOR
NUMROBRELISSIMAM PONDEREAUTEMSE
AMPISSIMAM INDEELEGIAOIUUANTEONObT

V INNOCENTILIS dicentio epo ezubino
ecclesiastica utrunta beatirapostolir

VI quae ftci corātchicoransdrīm p̄puero
isto - Oraui· & dodit mihi dñr pctitionem
meam quá postólaui eum, Idarco &ego -

VII Conrxichtiupeinc quantamorichohuy
uulo· Igtur gestulllurnonuc biradorn
pluybingahdaschasrtir pi erlyoin quuar

I ROMAN CAPITALS II SQUARE CAPITALS
III RUSTIC CAPITALS IV UNCIALS V HALF UNCIALS
VI CAROLINE MINUSCULE VII ITALIAN CURSIVE

I FRAGMENTUM LEGIS ROMANAE—CIRCA 500 A.D. II VIRGILIO, GEORGICHE—4th CENTURY
III VIRGILIO, ENEIDE—5th CENTURY IV EX AUGUSTINO PATAVIANO CORTICEO—7th CENTURY
V EX COLLECTIONE CANONUM—8th CENTURY VI LA BIBBIA DELL'ABATE DI CORBIE—8th CENT
VII OMILIE DI S. MASSIMO—9th CENTURY

I · IV · V · X—Di Re Diplomatica, Mabillon Ludovici Billaine, 1681.
II · III · VI to IX · XI to XIII—La Scrittura Cancellerie Italiane Federici, 1934.

S Iohs pbr oli pleban ecclesa bafe

Venditione facit natalif In conoue 7 in petronilla uxore suam 7 in infau

Actum Pompis palatio publice : Anno incarnata uobi Roberti gloriossimi regis XXXViiii al duius Cancell

De faciendo que erunt utilia pro stis mercatoribus. Ciuro qo de his que michi uidebuntur queuienta et uta

Rome in palatio ap.° in cam sancta d.n.pp. Die xiii Decembris Mcccc printz Reo: pre dno.B. archiepo Ra — pr dns Anselmus faber

sed pcessu cancellent, restituendo eu ad bona fama, et honores, et prout sperat Qua considerata la mercatum. tamen aiis expositis, et presertim q illud absq animo offendendi, sed defensionis causa co ce gra Ces et nra, potius q Juris rigore erga eu, vn decreuimus Proinde tenore prium Imp uide

diuersifiée pour toutes les Expeditions qui sen peuuent escrire.

**VIII COURT HAND IX PAPAL CHANCERY
DIPLOMATICA HAND XI BLACK LETTER XII CHANCERY CURSIVE
XIII ITALIC WRITING XIV ITALIENNE BASTARDE**

VIII CARTA GIUDIZIALE DEL DOGE VITALE MICHIELE I—1100 IX CON NOTA DORSALE—1191
X ROBERTI REGIS—12th CENTURY XI STATUTI DELLE CORPORAZIONI PISANE—1347
XII LIBER OFFICIALIUM EUGENI PAPAE IV—15th CENTURY
XIII DECRETO DI ALFONSO DE AVALOS—1544 XIV COPY BOOK—MIDDLE 17th CENTURY

XIV—L. Barbedor: Les Escritures Financière et Italienne Bastarda, 1659.
New York Public Library.

INTRODUCTION

WRITING and lettering is beyond doubt a universal art. All of us throughout our lives, are dependent upon it. Hardly a moment passes in our waking hours that we are not in some way reminded of its utility. Civilisation as we know it could not and would not have developed past the stone age without the written word. Without the alphabet, art would have been almost a useless thing. It could only serve to refresh the memory of the tribal story-teller. There could be no preservation of ideas.

From the time of our first scrawled A B C's until we learn how to write, we are all students of the alphabet. Too few of us preserve and protect for future generations the beauty of our rightful heritage.

No one person ever invented an alphabet. The forms have altered slowly and gradually with the tools and methods that were used to render them. Each craftsman in his turn used the forms that he inherited from former craftsmen, changing them only for the purposes of his own time.

The development of the alphabet, frequently called the greatest achievement of the human mind, in all countries and races will prove to be an unending source of interest to the student. For the story of writing is the story of mankind.

In the American Museum of Natural History in New York City are displayed the impressions of the feet of a dinosaur, left aeons ago in a peat marsh that eventually hardened into a coal deposit. That action, in principle, constituted the very method used by man in the earliest form of monumental writing.

The ancient Assyrians favoured this method, adopting a cuneal tool to impress the wet clay cake. Cuneiform writing resulted as surely from the shape of the tool employed as the shape of the impression of the dinosaur's foot came from the shape of his toe.

To appreciate the form of a letter one must first determine the type of tool used to form it, the method employed and the rapidity at which it was written.

The forms of the Chinese characters were influenced by the round brush used to render earlier carved pictographs. The Arabic and Hebraic forms show the result of a preference for the flat brush or reed.

The Roman capitals, the root source of our present-day letters, although the earliest forms have been preserved for us only in stone and metal, must have been evolved by the scribe working with a flat stiff brush or reed tool.

It is the general contention that the monumental inscriptions were first written by the letter artist and painted on the stone. The mason cut them in only for the sake of permanence. The natural distribution of the thicks and thins and the uniform grace and balance of the curves must have been determined by the rapid use of a flat instrument.

Lower-case letters came into use after centuries of transitional use of the capitals. Their forms are really a simpler, more rapid rendering of the capitals. The italic style of the same forms was caused by a more common use of writing, the tool employed and the writing surface becoming constantly finer. The slope resulted from a natural tendency to write faster.

The earliest forms of the Roman capitals, rustic and square capitals, upon examination suggest a flat pen or reed tool, cut square and held naturally, producing oblique thicks and thins. The curves tilt down on the left stroke and up on the right. There is a thickening of the horizontal strokes. The square pen held straight, instead of slanted, produced the Uncial and half Uncial forms; thin horizontal and thick vertical strokes, the round forms standing upright. The necessity for speed in writing was the first cause for the variation of the forms.

With the Caroline Minuscule, a refinement of the Cursive, developing with the revival of learning in Western Europe instituted by Charlemagne, there was a return to the more easily held slanting pen.

The free use of the slanting flat pen permitted the development of a bad habit, the condensing of the lateral curves to save space, and thus valuable skins, to the point that the curves became angular, giving rise to the so-called Gothic or Black letter still popular only in Germany.

After the introduction of paper in Spain by the Arabs about the early half of the twelfth century, the square stiff pen used with *even* pressure gave way to the softer blunt quill applied with *varied* pressure.

In the hands of the Papal scribes, who were becoming ingenious in the application of decorative forms borrowed from the East, the many Chancery, Charter and Diplomatic hands evolved. To prevent forgery, the medieval Popes had their edicts so bewilderingly executed that of necessity a legible copy was also produced to accompany them. During the fourteenth century the Papal offices derived an easily written slanting form from the Carolingian book script. Readily adopted by the merchants in their need for quick and readable writing, this Papal Chancery hand spread in time over most of Europe.

With the Renaissance in Italy there was a revival of the early classic Roman forms. Combining these with the current Cursive writing, the newly appearing writing master evolved the beautiful Italian hand. As commerce expanded, so the need of writing grew. Instruction books began to appear in great abundance. I have enjoyed the privilege of examining an original copy of the first ever issued, Sigismund Fanti's Manual, Venice, 1514. It contains, too, elaborate diagrams of the letters of Carolingian book hand and Roman capitals. It was the first to instruct the penman how to pick his paper, mix his ink, cut his quill and form his letters. The first to teach a script letter are two small volumes by Ludovico (Arrighi) Vincentino, Rome, 1522, printed from wood (or metal?) blocks engraved by Eustachio Celebrino. These show excellent Roman italic forms.

Printing in time took the place of the scribe and his book hand. Quills were cut

finer, the slit was made longer, one flourish fell over the other and the writing master had developed a new craft.

In learning to draw the various styles shown in this book, it is advisable to learn first to write them, that is train your hand to render them quickly. Use a soft pencil at first, a 3B or softer, sharpened to a flat square point, the width of the thick strokes of the style to be followed. Study the manner in which the tool forms the letter. By turning the flat pencil even the fine scripts may be quite accurately suggested. The turning of the pencil from the thins to the thicks approximates the pressure put on the flexible pen. Draw all examples larger, to a size best suited to your own hand, except those in the demonstration chapters—these were drawn the actual size they are reproduced and I feel should be copied exactly that size until they are thoroughly understood.

Do not worship the tool to the extent of becoming so clever with it that your conceit may bore the reader. Consider that your lettering has a message to convey to the patient reader. Never obscure the message by demonstrating how clever you can be. To see what this can lead to witness the work of the many misguided gentlemen of this and the last century who laboured and brought forth such abominations as so-called 'Rustic'—letters made to appear as though they were grown on trees and sawn off, and set up to form words and sentences at the cost of great patience—double initials, bricks and mortar and endless other absurdities. I call attention to these and other various eccentricities only to state my opinion, that they should be observed and avoided. The Romans had a script, but it became so shamefully degenerate that they abandoned it.

Carefully drawing a letter is one accomplishment, but applying it tastefully in association with others is quite another. Most of the incomprehensible work displayed to-day is due to a careless disregard for this truth. With the fine examples of alphabets extant, the near perfect reproduction methods and materials at hand developed by the efforts of countless craftsmen, it is deplorable that there is such a lack of plain intelligence in the use of these facilities. In many instances a 'production' condition has arisen in the rendering of hand-lettering so glaring in its lack of good taste that the work produced is detrimental to other fine art work with which it appears.

Reproduced herein are examples from the early copy books from which I have studied for many years. It is advisable for the student to consult original copies of these books and to read Ambrose Heal's *The English Writing Masters and their Copy Books*, the finest work on this subject to my knowledge.

The script letter was developed to its finest stage of beauty during the seventeenth and eighteenth centuries by the European penmen and engravers. The one to whom we owe the greatest debt, in my opinion, is George Bickham the elder (1684–1758), who in 1741 published a book of his engravings, *The Universal Penman*.[1] It contains

[1] A facsimile edition was published in 1954 by Dover Publications, Inc.

12

specimens of the work of the greatest penmen of that or any other century. I believe that this work will always stand alone as the finest endeavour in this field. Heal writes, 'George Bickham . . . attained a higher position as an engraver of calligraphy than as a practitioner of the art . . . excelling even his master, John Sturt.' Joseph Champion, who contributed forty-seven plates to Bickham's book, in the preface to his own *Parallel* writes, 'G. Bickham was the first English engraver who rightly dared to cut the letter through the wax on the copper (without first tracing it over as was the common practice) and thereby transmits the Ease, Spirit and Nature of the Master's Original.'

Thanks to Bickham for this wonderful record.

The burin and the pen came a long way together. At first they were bitter enemies, but five hundred years later the warmest of friends. In France a statute of 1260 read; 'No moulder may mould or cast anything with letters on it, and if he does so he will be at the King's mercy, himself and his goods; each letter must be made separately.'[1] The illuminators' guilds did not approve of reproduction methods. The glorious era of Intaglio engraving and the golden day of the master penman, however, dawned together.

Lettering, through all its transitional periods, shows more plainly than any other form of art the influence of the tool used in its rendering. Engraving eventually ruined the script letter. On pages 62, 63, 69 and 102 are reproduced specimens of the elegant work of Thomas Tompkins (1743–1816), master penman, who for forty years was employed by the City of London ' . . . to inscribe and embellish the addresses and honorary freedoms presented by that corporation.'[2] He attained the highest honours ever bestowed upon a penman, the commendations of four Princes. In 1777 he published a copy book, *The Beauties of Writing*. It shows a marked decadence from the Bickham standard of thirty-six years before.

Meanwhile, the copy books were doing their work well, people were learning to write a hand that looked like copper-plate engraving. If one did succeed, he doubtless became another master penman and carried on the tradition. A gradual decline of writing, however, took place during the nineteenth century. The steel pen era was greatly influenced by Tompkins. It is advisable for the student to consult the work of the earlier penmen.

Little has been contributed to the design of the script letter since Bickham's time save to cast its forms into type and, I must add, to tighten and often distort the characters to the will of the machine.

The artist-engraver and the master penman are of a past age. Pleasing, well-formed handwriting is now a rare accomplishment possessed by few. In the hands of the student and the designer of to-day rests the future beauty of the script forms or their eventual disfigurement.

The penmanship of the last century became very anaemic and rigid, sometimes

[1] André Blum, *The Origin and Early History of Engraving in France*, 1881.
[2] Ambrose Heal.

so fine and small that it was almost illegible. There would be no point in dwelling on this type of work as it could contribute little to the beginner.

In this Renaissance of the graphic arts the script letter has again won its rightful place. The application of bad forms in bad proportion to a formal purpose, such as an advertisement or the design of a book page or package is as unforgivable as any other display of questionable taste. The true form of the script letter is a product of centuries of breeding—as truly a thoroughbred in the world of the graphic arts as its distinguished ancestor, the Roman letter. The basic forms of the script letter should be known to the many gentlemen purchasing lettering, as well as they know Caslon type when they see it. I am sorry to observe that this is not always so. Patience should be exercised in working for the unknowing, to ensure that only the good forms are accepted.

I hope in this treatise fully to acquaint the student with the proper groundwork of the best script forms, and in explaining the construction of the round hand script I have called freely on a little copy book long in my possession: *The Art of Writing* by John Jenkins, 1813. This is perhaps the first copy book printed in America. Jenkins gave instruction in penmanship for fifty years, by his own calculation, before publishing his book.

I strongly urge the student's first attention to the basic strokes preceding the instruction chapters. Their likeness one to another and their dependence on each other may be plainly seen and readily understood by a study of the step-by-step examples. (Pages 21 and 28.)

All alphabets to be right must be based on a like number of principal strokes to the number composing the Roman capitals.

In natural design there are only these few elementary forms: spiral, circle, half circle, S form, waved line, straight line and zig-zag.

The forms composing the Roman capitals are: circle, half circle, straight line, (thin and thick lines, vertical and oblique, horizontal thin line), and S form.

The italicised capitals are the same but written faster, the circle becomes an oval and the half circles half ovals.

The script capitals are more quickly written forms, therefore the straight lines become waved lines and the oval and S form more condensed.

I would suggest the purchase of a set of 'Manuscript' pens of various widths, and a little time spent in roughly copying the early styles. Render them freely, writing them direct, stroke for stroke, to appreciate fully the fact that the character of the pen has formed the character of the letter.

All models and examples in this volume, unless otherwise credited, were executed by myself. My interpretations of the various forms should be studied by the student for what they are and not copied with too much devotion. He should consider

the principles of form, balance and construction which underlie them, then develop his own style. In mere imitation and copying, the novice can attain no individual growth.

If a new interpretation suggests itself to the beginner, by all means let him try it. He may easily abandon the idea and gain experience if it is not pleasing. Let him beware, however, that he is not merely developing a bad habit. The student must not think that he can invent anything. No one has, since the wheel, but we've all made a lot of discoveries.

<div align="right">

TOMMY THOMPSON
(Samuel Winfield Thompson)

</div>

In drawing lettering for reproduction it is best to train oneself to render the finished work as closely as possible to the size that it will eventually print; preferably no more than one-half larger, that is, the reproduction to be no less than two-thirds the size of the drawing. In this proportion of reduction the quality of the hand work remains evident. Greater reduction tends to tighten and harden the forms.

LUDOVICO VINCENTINO, ROME, 1522 (Metropolitan Museum of Art).

EQUIPMENT AND MATERIALS

A three-ply drawing board; An L. A. Starret Co's 24-inch tempered steel T-square; an 8-inch celluloid right triangle (transparent); Strathmore kid finish Bristol board; a pad of tracing paper; Venus or Dixon's drawing pencils: 5B, 4B, 3B, 2B, B, HB, 2H for sketching and drawing, and 6H for tracing; Higgins waterproof, black indian ink; Joseph Gillott's mapping pens No 291; Joseph Gillott's lithographic pens No 290; Eagle Pencil Co's pen holders No 1; Permo white (does not dry too rapidly, best suited for lettering because it does not pile up readily); Winsor & Newton's lamp black. Water-colour brushes; Winsor & Newton's small and large, short rigger brushes, Nos 1, 2, 3, 4; short one-piece thumb tacks or drawing pins; a water jar; Venus soft white erasers.

> To explain my use of these particular trade names, I can only say that I have found these products superior to many others that I have tried.
> A three-ply drawing board will not warp or become out of square. It is used to thumb tack (pin) the drawing on. It can be turned and shifted about as you work, supported on the edge or top of a table. As the edges are in square they become the guide for your T-square.
> A steel T-square will remain more accurate than a wooden or celluloid one. It is used to establish parallel horizontal lines, and as a guide on which to slide the triangle to rule even slant lines. The celluloid triangle is transparent thereby keeping the entire drawing on which you work visible. Strathmore kid finish Bristol board, because of its particular tooth, is in my opinion best suited for lettering, although many lettering men prefer a smoother surface.

The tracing paper must be transparent, but stout enough not to wrinkle under your hand. The form, spacing and proportions of your lettering should be carried out on tracing paper in soft lead pencil, using harder pencils in correcting to a fair degree of accuracy before tracing through to the Bristol board. This is done by putting each attempt to be improved upon beneath a fresh sheet of paper, re-ruling the horizontal and slant lines and then re-drawing and correcting. The former attempt may be shifted about under the new sheet until the desired result is accomplished. The whole may now be tacked in position over the Bristol board on the

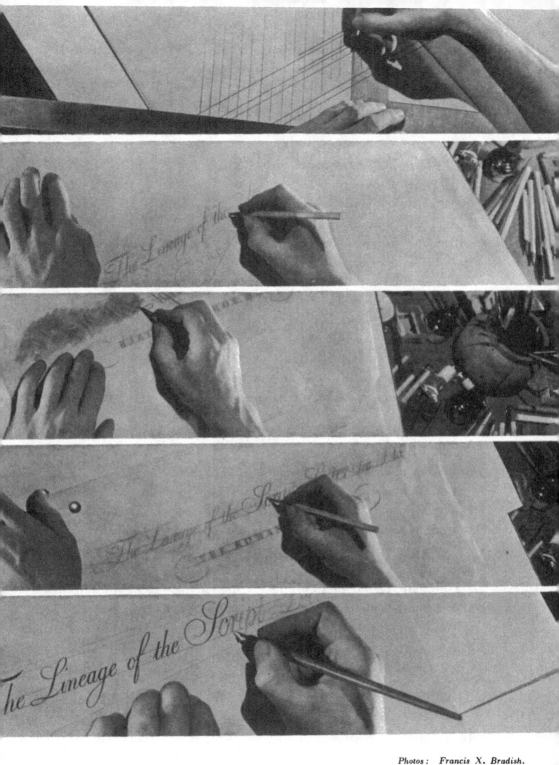

Photos: Francis X. Bradish.

ng guide lines. 2. Layout—sketching—planning. 3. Blacking back of accepted tracing.

4. Tracing through to Bristol board. 5. Inking—continuing thin line to next letter.

drawing board and traced through in outline with a hard pencil, after blacking and smudging the back of the tracing with an HB or 2H pencil and your fingers. Dust off well before tracing through.

By doing all preliminary drawing on tracing paper, the surface of the Bristol board is preserved for the fine pen line so necessary to this letter.

The lettering is now ready to be inked.

All pencil lines may be removed after the ink is dry with a soft eraser.

All mistakes made in inking, such as too heavy lines, etc., can be corrected by applying white, with a small brush, after it has been thinned with water to flow from the brush smoothly. If a mistake is made with the white it may in turn be covered with lamp black in the same manner. Ink from the pen will not lie opaque over water-colour white.

The best method of all, however, is to learn to draw accurately rather than to depend upon any corrective methods.

To show the direction of the pen in inking, I present on pages 40 and 41 a chart of the principal strokes. From this may be learned the proper strokes of the pen to form the hair lines and the outlines of the letters. It only remains now to fill in the outlines, and the lettering will be complete.

The drawing may be turned about as you work to follow the directions shown if it proves too difficult to draw a pen stroke away from the body instead of toward it (the most natural and easiest stroke).

You will now be continuously drawing your pen or brush toward yourself, forming the curves by turning the paper. Return the drawing to upright position frequently to compare the proper forms.

This chart will be found useful in drawing the letters in pencil as well as in ink.

I present this method only as my individual way of working. I must add that other methods can show just as satisfactory a result.

To understand thoroughly the use of materials, the process of scaling drawings, reproduction methods, etc., the student is advised to consult Gordon Aymar's *An Introduction to Advertising Illustration* (1929).

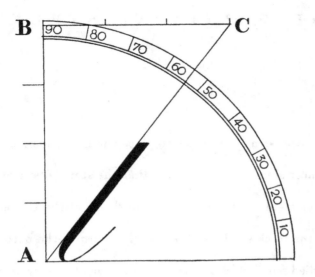

THE SLOPE

THE slope of the letters of the round hand alphabet is about 54 degrees. It may be determined by the following means: draw a perpendicular line and, across it, two parallel horizontal lines twice the distance apart of the height of your intended stem. Space the distance A-B into four equal parts. With your dividers take three-fourths of the perpendicular line. At the intersection B, place one leg of the dividers, the other leg will find the point C. Draw an oblique line from A to C. This will be the proper slope for the letters.

Other slopes which may be followed for guidance are: Single-weight letter—57 degrees; Free Style—48 degrees; Bâtarde—60 degrees; early specimens of Bâtarde are as upright as 68 degrees. The faster a letter was written in its development, the greater the slant became.

IT may seem strange to some to place the L as the first stroke, as it is not the most simple. The reason is that the stem is perfectly included in the L. The stem is drawn, after a knowledge of the L is acquired, by continuing the thick stroke to the line. The turn at the bottom of the L is to be studied particularly. When a knowledge of this stroke is acquired, one has learned the turn of all the other letters in the alphabet, as they are all turned alike. See pages 42–45.

IN writing, this turn represents a two-fold motion of the pen; a downward stroke with pressure, and the rise of the pen, lightly.

IT will be observed that three of the principal strokes are perfect letters. These three letters, the L, J and O, by themselves and differently joined, make fourteen letters. Therefore, when one can draw these six strokes accurately, one will be complete master of fourteen small letters (except the mere matter of joining them) and parts of several capitals.

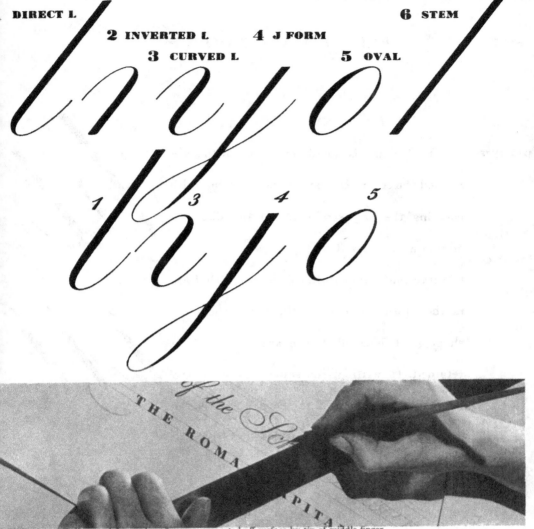

DIRECT L 6 STEM

2 INVERTED L 4 J FORM

3 CURVED L 5 OVAL

1 3 4 5

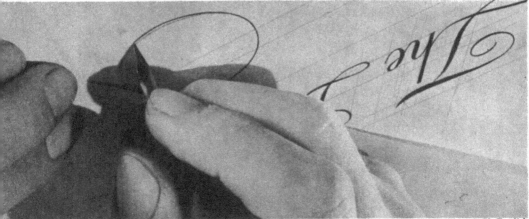

Ruling straights—edge of square supported off surface by tip of middle finger.

Turning drawing to follow curves, drawing pen toward self. Photos: Francis X. Bradish.

DIRECT L **I** The first is the direct L; and of this are formed the A and D; the B is made of the L by carrying the hair stroke up to the line and adding a slight swell.

Observe that although the T and the little I are neither drawn as long as the L yet the same shape and idea of the character is to be retained. In writing, the same motion of the fingers and pressure of the pen is exerted, as each of these letters is but the lower part of the L.

It is easy to discern that the two I's form the U.

The I is drawn on the right side of the O to form the A.

The I. is drawn on the right side of the O to form the D.

The J is drawn on the right side of the I to form the Y.

The J is drawn on the right side of the O to form the G.

The J inverted and protracted a little forms the straight F.

The J surmounted by the inverted J forms the running F.

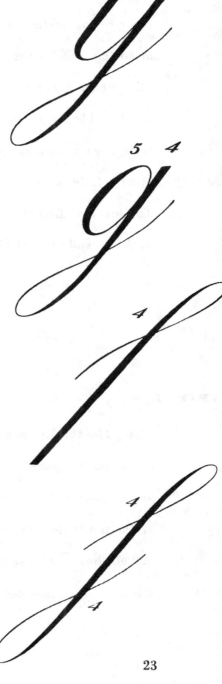

INVERTED L

2 The second stroke is the inverted L, or the direct L drawn bottom upward. Both the inverted L and curved L should be studied and drawn quite as carefully as the direct L by the beginner, for their dependence on each other will then be much more easily understood and retained.

Particular care must be taken to understand the meaning of the word 'inverted.' By this means one will sooner acquire a knowledge of this stroke. A number of direct and inverted L's should be drawn and studied to observe the turn of each until the exact likeness to each other is fully perceived.

The inverted L is the first and second stroke of the M, and the first of the N and R.

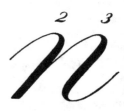

CURVED L

3 The third stroke is the curved L. This stroke may be said to include both the direct and inverted L̇; for observe, all below the break at the top is the same stroke as the direct L; and all above the break at the bottom is exactly the form of the inverted L.

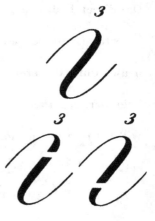

The curved L is the last stroke in the M, N, H and P; and the first of the Y, V and W. The V and W are completed by carrying the hair stroke up to the line and adding a slight swell like that of the B.

☞ LET it be remembered that much of the beauty as well as the legibility of this letter depends upon the body of the curved L being drawn perfectly straight.

THE J

4 The fourth stroke is the J. The J drawn on the right side of the O forms the G; and drawn on the right of the curved L forms the Y. The J combined with the inverted J forms the F, as previously shown.

THE OVAL 5 The fifth stroke is the O, which is the root form of the A, C, D, E, G, Q and X. The C is made of the left side of the O, by adding an inverted comma at the top. The E is also formed by drawing up a curved hair stroke from the centre of the space to the top, from which draw down the left side of the O as for the C.

The X is formed by the combination of two C's; the first being inverted and the other drawn direct and joined to the first.

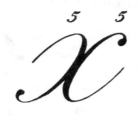

THE STEM 6 The last stroke is the stem. This stroke as observed, is contained in the L.

The stem is the first stroke of the H, P and K, and the second in the Q. The K is made by adding the inverted C and the curved L to the stem.

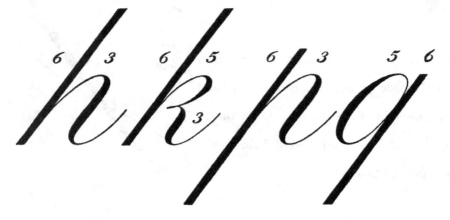

 THE little S and the Z are the exceptions. They are drawn as the examples show. The little Z is formed like the capital Z, shown on page 33. See also page 45.

From the foregoing observations the utility of learning by heart the various combinations of strokes will at once appear. The scheme of dependence of the letters upon these principal strokes and of one letter upon another, will for all time be acquired.

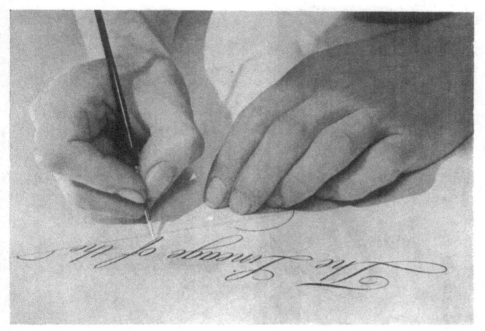

Finish, correction with white. *Photo: Francis X. Bradish.*

FORMATION OF THE CAPITALS

THE PRINCIPAL STROKES

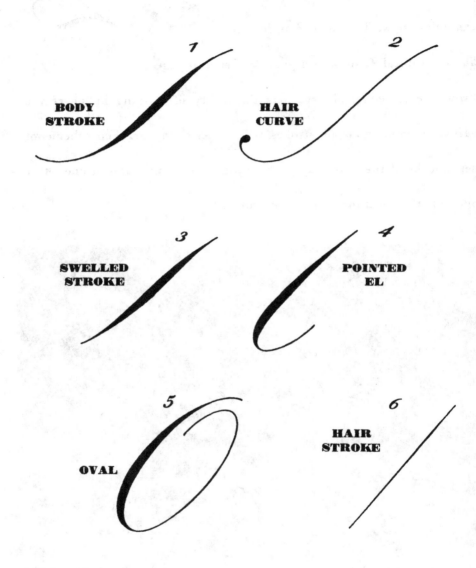

BODY STROKE

HAIR CURVE

SWELLED STROKE

POINTED EL

OVAL

HAIR STROKE

I AND J

The I is formed of a waved stroke, the body stroke and a reversed comma.

The J is the same, but finished at the base with a loop as in the J form (4), page 21.

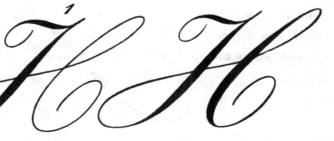

H

The H is formed of the I by adding the C, page 33.

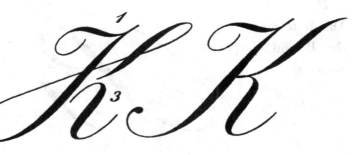

K

The K is formed of the I and the swelled stroke combined with the curved L (3), page 21.

T AND F

The T is formed of the waved line and the body stroke. The F is distinguished from the T by being crossed in the centre.

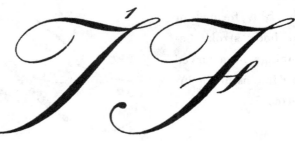

P

The P is formed of the body stroke and a circular swelled stroke.

R

The R is formed of the P and the curved L, finished as the K.

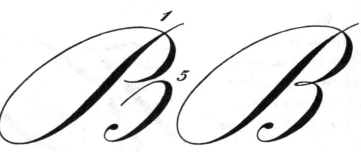

B

The B is formed of the P and the inverted C.

S

The S is formed of the body stroke beginning with a curved hair line as in the inverted J.

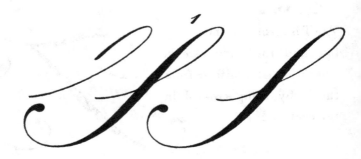

30

L

The L is formed of the body of the S by adding a waved stroke at the bottom.

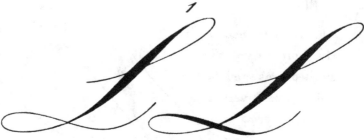

D

The D is formed by turning the body stroke like the L, continuing a circular hair line around top into a spiral.

U AND V

The U is formed of a curved L and a direct L.

The V is formed of a curved L and a reversed comma.

A

The A is formed of the hair curve and pointed L, crossed at a point slightly above the centre.

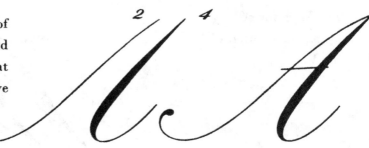

N

The N is formed of the hair curve, the swelled stroke and the hair curve inverted.

M

The M contains the first two strokes of the N, the hair stroke and pointed L.

V

The V is formed of the waved stroke, the swelled stroke and inverted hair curve.

W

The W is formed by a simple variation of the V.

Z

The Z is formed of two waved strokes and a hair stroke.

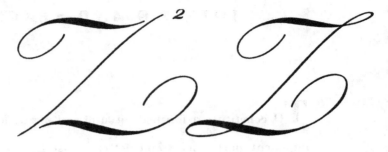

C AND E

The C is formed of the left side of the oval.

The C indented forms the E.

Q AND X

The Q is formed of the inverted C and a waved stroke.

The X is formed of the inverted C and the direct C.

Y AND G

The Y is formed of the curved L and the J, see page 21.

The G is formed of the C and the small J.

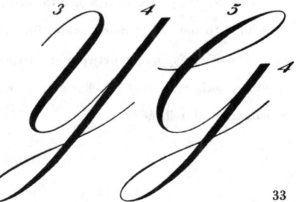

JOINING AND SPACING

To constitute a finished piece of writing or lettering, not only the component parts and whole letters must be justly proportioned, but particular attention must be paid to the uniform distance at which one letter is to be drawn from the other.

The rule and manner of joining must be understood in the accurate joining of one letter to another, and different letters differently joined.

The following examples are introduced to show the proper and uniform distance of the letters from each other, and also the place at which one letter ought to join the other.

The examples in spacing are introduced for whatever aid they may be to the beginner.

In using the inward width of the small N as a unit of measurement, I imply the area of white space enclosed by that letter. Measure it only with your eye.

I have seen the plan used in which the areas between letters have been filled in with tone for demonstration. But, in my theory of design, no space should be apparent between the letters—the letters should flow together, each conveying its character to the eye to form the words, which, after all, tell the story.

CLASS 1 Right line letters joined together, as u-i, n-i etc. They are joined by continuing a hair stroke from the bottom of the preceding letter up half the space to join the following letter. The distance letters of this class are to be drawn from each other is the inward width of N.

CLASS 2 Right line letters coming before and joined to ovals and half ovals: as u-e, i-o. (The oval letters are o, a, d, g, q, b, v and w. The half ovals are c, e and x.) They are joined from the bottom of the right line letters to the ovals and half ovals, in the middle of their height. Distance, the inward width of N.

CLASS 3 Half oval letters prefixed to right lined letters as, c-i, e-i etc. These are joined in the middle of the space at the distance of one and a half the inward width of N.

CLASS 4 Half ovals; c, e and x coming before and joined to ovals and half ovals. These are joined from the bottom of the preceding letters to the

35

middle of the following letters as in the first, second and third classes. Distance, one and a half the inward width of N.

CLASS 5 Such right line letters as join each other with double turns; or such as join from the bottom of the preceding to the top of the following as i-n, a-r etc. Because of their double turns, the distance is one and a half the inward width of N.

CLASS 6 Half ovals coming before and joined to right line letters from the bottom to the top, with double turns. Because of the circle of the half oval their distance is twice the inward width of N.

CLASS 7 The o, coming before n, m, r, u etc, and joined from the top of the o to the top of the following letter. The distance is the inward width of N.

CLASS 8 When r-r, r-n, r-v etc, are joined to each other by a curving hair line from top to top. Distance one and a half the inward width of N. The beginner is reminded, when joining letters of the fifth, sixth, seventh and eighth classes, to guard against making the top turns too shallow.

CLASS 9 Two or more ovals meeting; as o-o, v-o, and joined by a curved hair stroke, about one-third from the top of each. Distance, one-half of the inward width of N.

CLASS 10 The e, following and joined to v, b, r, o and w. From these letters draw down a curved hair stroke, near the middle of the space; then rise to the line, looping the e. Distance, one-half of the inward width of N.

CLASS 11 J, g, y and f, coming before and joining in the middle of the space to all letters except the s, and those beginning with top turns.

Distance, the inward width of N. The beginner is reminded that the ascending hair strokes of the j, g, y and f cross their stems about an eighth of an inch below the line, in this size; and that the e, when following these letters, is looped with a continued hair line.

CLASS 12 Right line letters coming before and joined to f in the middle of their height; at the distance of the inward width of N.

CLASS 12a The o or r, coming before f is joined by a hair line brought down as in the seventh class, and looped in the f as the e is looped in the tenth class. Distance of double the inward width of N.

CLASS 13 Right line letters coming before and joining the s from the bottom, at the distance of twice the inward width of N.

CLASS 13a Half ovals coming before and joining the s from the bottom. Because of the circles of the half ovals and the s, the distance is twice and a half the inward width of N.

38

CLASS 14 The letter s following r, b, o, v and w. The hair stroke from the preceding letter is connected to the top of the s, curving down half way. Distance is varied by the form of the letter preceding.

CLASS 15 The letter s preceding right line letters, i, h, y etc; connect from the bottom half way up. Distance of the inward width of N.

CLASS 16 The s preceding oval and half oval letters, e, c, o etc; half way up from bottom at inward width of N.

CLASS 17 The s preceding inverted L letters, n, r, m etc; connect from bottom to top at one and a half the inward width of N.

The distance between the last letter of one word and the first letter of the next, should be the width of N greater than between the same letters when joined in one word. Where a full stop is used, the space is increased to twice the width of N. All other joinings, and the distance between the letters will be ascertained by a close study of the foregoing examples. Careful practice will render all of these joinings familiar.

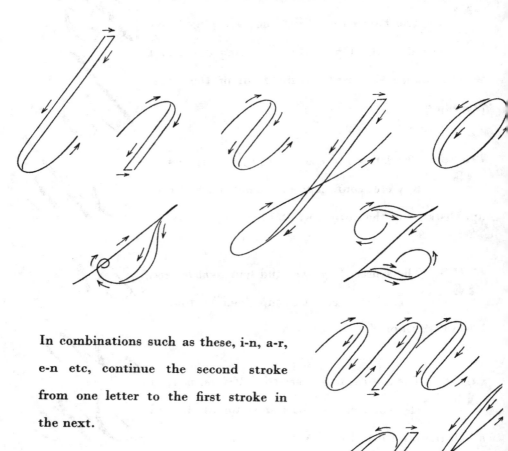

In combinations such as these, i-n, a-r, e-n etc, continue the second stroke from one letter to the first stroke in the next.

In such combinations, r-e, v-i, o-e etc, follow through in this manner.

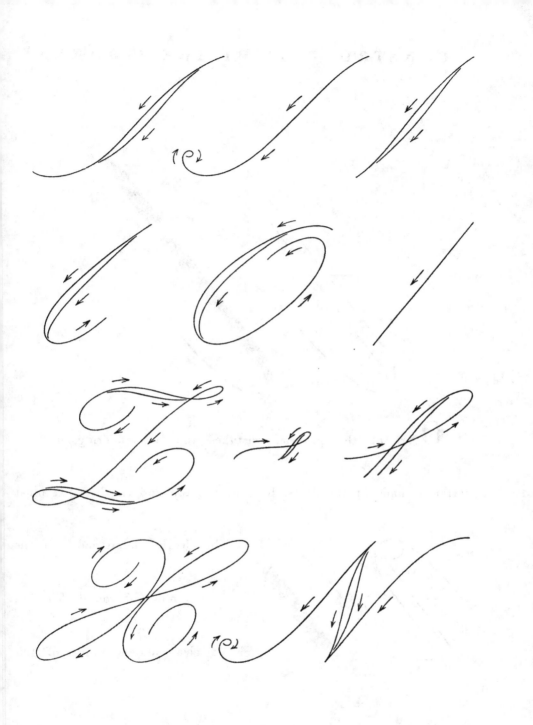

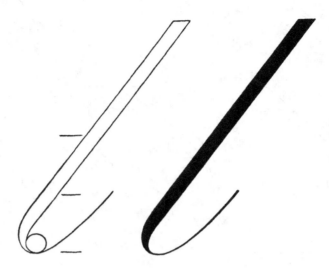

O<small>NE</small> of the gravest mistakes in the rendering of this letter is made at the turns, both at the top and the base. It must

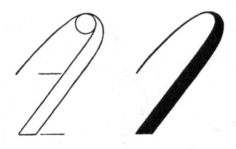

be clearly understood that the turns must be round. Without a clear understanding of this

fact no great mastery of this

form is possible.

I do not mean that it is

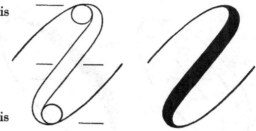

necessary to draw the circles before drawing the letter. Rather, imagine

them as the turn is made, to avoid stiffness.

No matter what the style of script being employed, or however

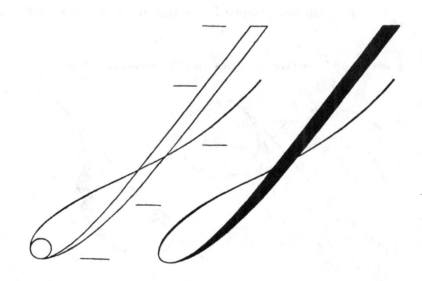

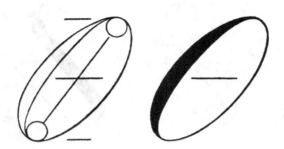

condensed it may be of

necessity drawn, this simple

rule must be observed.

Legibility of the message portrayed is as dependent on this rule of

rounded turns, as it is on the rule that the stems must be perfectly

straight.

I place particular emphasis on this principle; the curves must be

graceful and the straight lines must be straight.

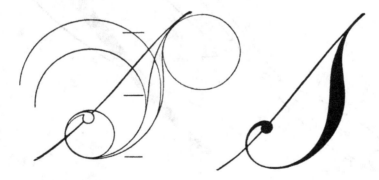

The circles of varied areas are used in the examples of the S and Z to show that there is no monotony in their structure, and to aid the student in his observation of their form.

These examples if studied carefully and copied faithfully will give the student a lasting foundation on which to build his future work. It is advisable for him to return frequently, as he advances in skill, to these basic forms.

His work cannot be sound without a mastery of structure.

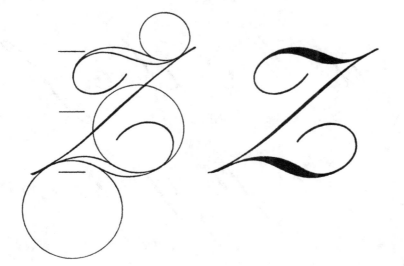

A B C D

I J K L M

R S T U V

a b c d e f g

o p q r s t

E F G H

N O P Q

V W X Y Z

h i j k l m n

u v w x y z

CONSTRUCTION OF THE NUMERALS

THE STROKES

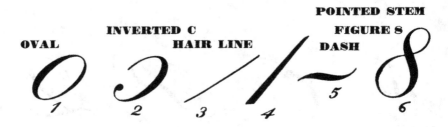

IT will be observed that all of the six strokes used to compose the

numerals are similar to the strokes used in the alphabet with which you

are now acquainted.

The O and the C are inverted, the hair line follows a different slant

and the dash is merely a part of the waved line. The figure 8 is formed

with the top loop smaller than the bottom one for the sake of its grace-

fulness. The bold stroke will be found to be not unlike that of the body

stroke (see page 28).

The 1 is made by the addition of a short hair line to the top of the stem.

The 4 being similar is shown next. The hair line is drawn down from

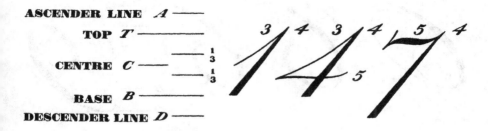

the top about two-thirds of the height of the stem. The stem is then

crossed with a horizontal waved line or dash.

The 7 is drawn with a short inverted stem, almost a third of the

space down. To which is added a dash and pointed stem. The stem may

also be made with less weight even to the thinness of a hair line. It

extends below the base, to the descender line.

The 3 is formed of two inverted C's, omitting the comma and adding

a slight swelling to the first curved line.

The 5 also employs the inverted C for its base with a hair line and is

finished with one half of the dash.

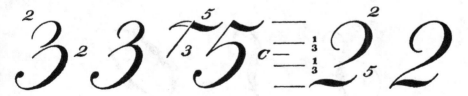

The C in the 2 is similar to that in the 3, but larger. The down curve is continued to the base line, where it is joined with the dash.

The 6 is drawn to a size to reach the ascender line. It is based on the curve of the oval used in the strokes of the capital letters. The bold stroke of the oval is joined to the stroke of the inverted C.

The 9 is the same as the 6 except that it is drawn from the top line, below the base to the descender line.

The cipher is exactly the same as the oval or it may be drawn as the capital O is drawn.

ROUND HAND

1 2 3 4 5 6 7 8 9 0

BÂTARDE

1 2 3 4 5 6 7 8 9 0

SINGLE STROKE

1 2 3 4 5 6 7 8 9 0

FREE STYLE

1 2 3 4 5 6 7 8 9 0

Massey* says that the so-called Arabic numerals were not common in Europe until after the year 1300. Most evidence points to the probability that they were first brought to England by Richard I, from the Holy wars, possibly learned from the Saracens.

* William Massey "The Origin and Progress of Letters," 1763.

51

THE FLOURISH

As the preceding examples were intended to explain construction all needless flourishes have been omitted. Flourishes if not used tastefully obscure rather than enhance the simple form of the letter or design. They should at no time be employed unless they definitely complement the particular letter, word, sentence or page to which they are applied. (See examples page 56).

They have their usefulness, however; when they appear to have been written spontaneously, as they should, they are very beautiful. No two swells, spaces contained, or turns are ever quite the same. Therein lies their charm. No two penmen or lettering men, to my knowledge, have used them in quite the same manner. They remain a personal element of design. I present here the fundamental forms to aid the student in his own analysis. After a perfect idea of the script letter is well fixed in his mind, the student will naturally use as many ornamental strokes as he will find necessary or desirable. May I advise, never allow a letter to depend on a flourish.

THE PRIMARY ELEMENTS

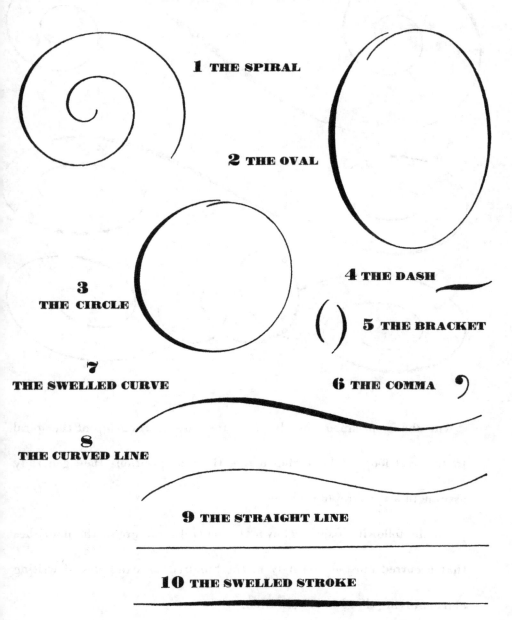

1 THE SPIRAL

2 THE OVAL

3 THE CIRCLE

4 THE DASH

5 THE BRACKET

7 THE SWELLED CURVE

6 THE COMMA

8 THE CURVED LINE

9 THE STRAIGHT LINE

10 THE SWELLED STROKE

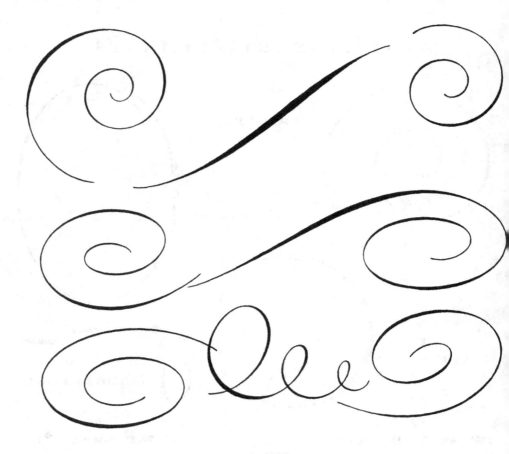

The above specimens merely prove the close relationship of the spiral to the oval loops. I have shown too, the four positions they generally assume in a typographic scheme.

On the following page is shown the general structure of the flourishes that occurred most flatteringly in the hundreds of examples of writing and engraving that I have consulted.

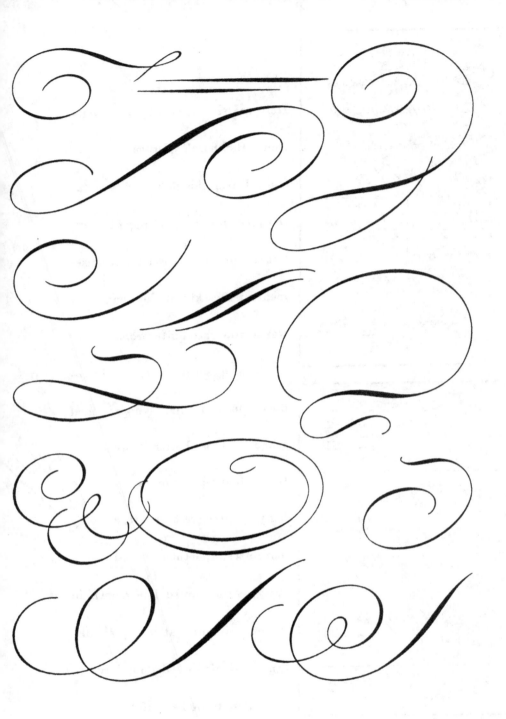

Here are shown two typical pages from Bickham's *Universal Penman*. I feel the flourishes are far too plentiful for good page layout, but as the book was an advertisement of the skill of the penman it was in this case quite proper.

When a script letter is introduced in a formal typographical scheme, it is better taste to use flourishes more sparingly. I suggest in the margin a simple theme based only on the waved line drawn in various weights at unequal distances. Flourishes do not have to be endless to be beautiful.

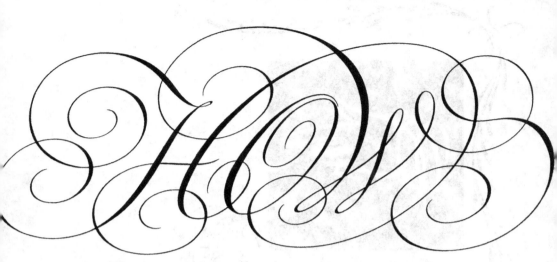

In analysis it will be found that these cartouches were composed by metre. Master the principle, and the combinations become endless.

Specimens from *The Universal Penman*, George Bickham, London, 1741.

THE game of designing the flourish elements into new forms and counterbalances can be a pleasant adventure. Some recent compositions are here assembled with a few from the past.

In the margins of this page is a Christmas decoration for *Family Weekly Magazine*. The three rough design sketches are for Shulton's Old Spice; the initial letter is for Raleigh Cigarettes; the three cartouches below were drawn for Time Instruments Corp. At the top of this page is a pattern drawing from which Baltimore Type and Comp. Corp. engraved and cast the type fists to complement a new typeface, Baltimore Script, designed by the author.

The typographic braces on the opposite page were executed for *Mademoiselle* magazine. The script headline and flourishes were rendered for Mount Vernon Distillers Products Corp.

The Present toasts the Past in Mount Vernon!

Fit for a Long Life

The crest and oval is from the master drawing for a paper embossing die.

The flourished headline above is a part of the preliminary work used in developing the new Old Golds cigarettes package design. The magazine heading to the left is by courtesy of *The Woman's Home Companion*, while the flowers tell the Pacquin story. An attempt is made in these designs to make the flourishes blend with and become part of the lettering rather than merely to accent or underscore it.

The largest-selling hand Cream in the world.

Pacquins HAND 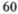 CREAM

These astonishing pen strokes by Barbedor are presented here for sheer inspiration rather than as a specimen to be copied. They are part of the alphabet of Italienne bastarde capitals. I suggest the possibility of evolving a modern letter form utilising the freedom of these seventeenth century characters.

York Public Library)

Barbedor

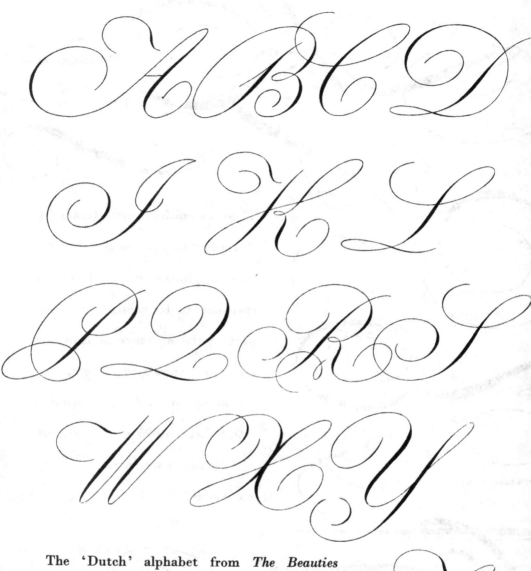

The 'Dutch' alphabet from *The Beauties of Writing*, by Thomas Tompkins, 1777, engraved by Ellis. The letter N in this specimen was too obsolete for present-day use, and I have redrawn it. Note the difference between a

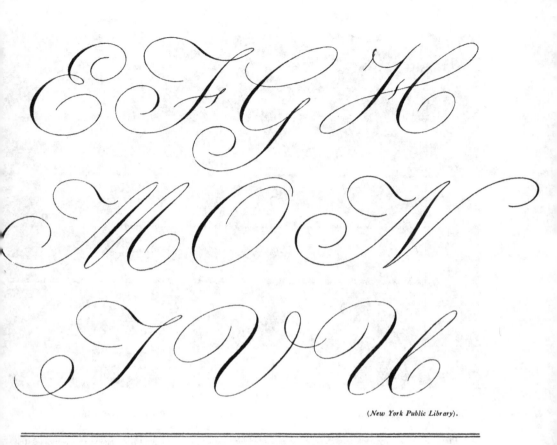

drawn pen line and an engraved line. These capitals may be combined with the small letters of the Round Hand, rendered of course in the same weight, where a decorative flair is desired.

In the course of your study of this style of letter please consider that the flourish does not form the letter, it is an accessory to it. The basic form is that of the Round Hand (pages 74 and 75).

Edward Cocker, England, (1631–1676). Page from *Art's Glory*, 1657.

Plates for this copy book must have been reprinted for over 63 years, for the third page in this copy is dated 1730, page 9 bears the date 1669 and page 24, 1668.

The examples are based on the best Italian forms. Many pages are decorated with ornamental patterns and flourishes. Massey mentions that Cocker engraved and published over twenty different copy books besides founding several schools for the instruction of writing. 'He was certainly a great encourager of various kinds of learning; an indefatigable performer both with the pen and the burin.'[1]

He was one of the first to bring the Italian script forms to England, but he '. . . never flourished financially and he died "within the rules of the King's Bench Prison* close to his old school."'[2]

[1] William Massey, *The origin and progress of letters*, 1763. *Southwark.
[2] Ambrose Heal, *The English Writing Masters*, 1931.

Other Copy Books { *The Pen's Triumph*, 1657 *The Pen's Perfection*, 1672
 by Cocker { *The Artist's Glory*, 1659 *Compleat Writing Master*, 1676

abcddeffghillmnoppqrfsœt
vuxyyzzz.

AAAABBBCDEFFGHHgJIL
LMMMNNOPQQRRSTT
VVVXHYYYZZ.

Louis Barbedor, France.

'Secretaire ordinaire de la Chambre du Roy,' Ordinarily employed in the expertising of writing and contested signatures. Secretary of Ancient Syndic of Master Writers of Paris.

In the preface to his *Traite de l'Art d'Escrire* he writes very modestly of his own accomplishments, acknowledging his predecessor, Jean De Beaugrand.

He wrote a free, bold hand with beautiful flourishes. His work set an excellent standard for the penmen of his own day and greatly influenced later English penmen.

Top examples from: *Les ecritures Financiere et Italienne Bastarda*, 1659.　　*(New York Public Library).*
Lower examples from: *Traite de l'Art d'Escrire Italienne Bastarde*, 1655.　　*(Metropolitan Museum of Art).*
　　　　　　　　　　　　　　　　　　　　　　　　　Engraved by Robertus Cordier.

ABC'DEFGHIL
MNOPQQRS'
TVXYZ.

*abbccddeffgghhjilillmnopp*q
qgzxrrfsstvuxyzzz

German Text.

Aabcdeffghijklmnopqrsſtuvwxyzz.

ABCDEFGHIKLM
NOPQRSTVWXYZ

Round Text.

Aabbcdefffghhhhijkkkllmn
oppqqrzsſsttuvvnxxyſyyz

Square Text.

ABCDEFGHIJKLM,
abcdefffghijklmnopqzeſtuvwxyz
NOPQRSTVWXYZ

Round Hand.

abbcddefoghhijkkllmnnoppqrsſstuvnxyz.
ABCDEFGHIJHLMMCM
NNOP2RSTUVWXXYYZ.

Engraving.

Aa.Bb.Ct.Dd.Ee.Ff.Gg.Hh.Ji.Jij.kk.Ll.Mm.Nn.Oo.
Pp.2q.Rr.Sſs.Tt.Uu.Vv.Ww.Xx.Yy.Zz.

Secretary

Aaubuitndmeusfugmhimijukmluuompurqurssutuvvoxuyzz
ABCDEFGHIJKLMNOP2RSTVWXYZ.

Joseph Champion Scr.

Specimens from *The Universal Penman*, 1741.

Written by Joseph Champion. Engraved by George Bickham.

Old English Print.

Aabcdefghijklmnopqzrſsſſtuvwxyz.xc.

ABCDEFGHIJKLMNOP

QRSTUWXYZZJC.

Italick Print.

Aabcdefghijklmnopqrſstuvwwxyz.æœ.

ABCDEFGHIJKLMNOPQR

RSTUVWXYYZÆ.

Roman Print.

Aabcdefghijklmnopqrſstuvwxyz.

ABCDEFGHIJKLMNOPQ

RSTUVWXYZ.

Italian Hand.

aabbccddeefffoghbijskkllmmnoppqrsſsttuvvxyzz.

ABCDEFGHIJKLLMMN

NOP2RSTUVWWXXYZZ.

Court Hand.

ſſaꝛoꝛꝶꝶꝶoffffꝺꝶꝶꝶijꝶꝶꝶꝓꝛꝶꝶꝶꝶoꝍꝓꝑꝺꝶꝶꝶꝶꝶꝶꝺꝶꝶꝶꝶꝶꝓꝓꝓzzz.

........The Chancery........

AaꝶꝶꝶꝺꝶꝶEeꝶꝶꝶꝶꜵꝶꝶꝶꝶꜵꜵꝶꝶꝶꝶꝶꝶꜵꝶꝶꝶꝶꝶꝶ

~ ꝶoPpꝶꝶqRrzꝶꝶꜵꜵꜵꝺꝶꝶꝶXxYyZzzt. Champion Scrip.

Copy books by Champion. *The Parallel or Comparative Penmanship Exemplified*, 1750.
Practical Arithmetic, 1733. *The Young Penman's Daily Practice*, 1760. *The Penman's Employment*, 1762.

L. Barbedor M. Escriuain
Juré a Paris pour la verification des Escritures et Signatures.

Literis tamquam rei immortalitati pr-
-mæ hoc debemus, quod consulere alijs po,

Useful Attainments in your Minority,
will procure Riches in Maturity; of which

Roman Forms—From Financiere into Round Hand.
(New York Public Library).

bjects of a rational pursuit,

rnaments to human nature

haracters to a virtuous and

Received August 3ᵈ 1774. of Joseph

Kennington Esqʳ Five hundred & twenty

Seven Pounds in full —

£ 527 —

N Lenogle.

Specimens from *The Beauties of Writing,* 1777.

Ama,
Bmb,
Cmcc,
Dmd,
Emee,
Fmff,

Gmgg,
Hmhi,
Imyjh,
Kmki,
Lmllo,
Mmu,

Charles Snell (1667–1733), England.

The above is a fine specimen of the English Round Hand in its formative state, reproduced actual size.

It is evident that Snell was influenced by the copy books of Barbedor. The capitals B, F, L, M, P, S and T are very similar to Barbedor's Italian forms. Also observe the small f in the first panel, and the u with the straight serif in the second and third.

Snell's distinguished pupil Joseph Champion, almost completely eliminated these French characteristics in his Round Hand. (See Round Hand example, page 66.)

Nine pages of this copy book were written by Snell. He published several copy books of his own in which, 'The standardisation of writing characters which he advocated . . . was largely answerable for in the decline

Alphabet from *The Art of Writing*, 1712—engraved by George Bickham.

Nmnn,

Omooo,

Pmpp,

2mqu,

Rmrr,

Smfss,

Tmtttu,

Vllvu

Wmv,

Xmx,

Ymyjy,

Zmz,

of writing which set in during the first two decades of the eighteenth century.'

Quotation—Ambrose Heal, *The English Writing Masters.*

'It was a strong genius, and a constant industry, and copying after the engraved works of Barbedor, that produced that correctness, and beauty, which are so conspicuous in his copy books.'

Massey, *The Origin and Progress of Letters,* 1763.

'. . . Bold Barbedor in freedom did excell,
But this last worthy was revived in Snell.'

Mr. Sinclare, 1763.

Another copy book by Snell, *The Penman's Treasury Open'd,* 1694.

The Sense of Honour is of so fine and delicate a nature, that it is only to be met with in minds which Demands. Encomium. Fraternity. Round Text Copies,

Willington Clark (1715–1755), England.

Examples from George Bickham's *The Universal Penman*. Pages dated 1635.

These pages are presented as examples of excellence in writing and engraving. They were produced at a time when the English Round Hand had attained its finest state of development.

'This gentleman gave early proofs of a promising genius for the advancement of elegant penmanship; for he writ twenty-two pieces, well executed, in various hands, for Geo. Bickham's *Universal*

Penman, some of which were performed before he was twenty years of age. He was brought up, and educated under his father, who kept a writing school in the Park, Southwark . . . he went into the Exchequer; where he was chief clerk for making out exchequer bills.'*

* William Massey, *The Origin and Progress of Letters.*

73

Aa Bbb

Ee $Ffff$ Gg

Kk Lll Nn

Qqu Rrr Ss

Ww Xx

Cc Dd

Hhh Ii Jj

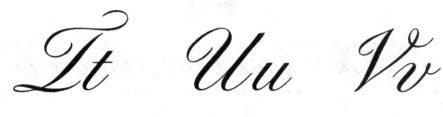

Mm Oo Ppp

Tt Uu Vv

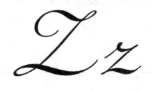

Yy Zz

P. Lorillard Company
Established 1760

*A Famous Name in Tobacco
for nearly 200 Years*

KNOX

The Knox "One Hundred"
WITH VALET CARRYING CASE

One Hundred Dollars

Old Golds 50s package. P. Lorillard Company.
Knox 'One Hundred' display card. Knox Hats.

Three Ways to Bath Enchantment

The Fatal Kiss

Disregarding her physician's strict injunction, Princess Alice, second daughter of Queen Victoria, embraced her afflicted child.

Help Yourself to Beauty

Bride's Privilege

By WILLIAM E. BARRETT

J

1. Shulton—Old Spice. 2. Parke Davis.
3. *Charm* magazine. 4.*The Saturday Evening Post.*

Lettres Bâtardes Française

A constructive form of censorship took place in France in the life of the script letter. Stanley Morison writes in *The Graphic Arts*, 'In the middle of the seventeenth century, Colbert, when Louis XIV's financial secretary, took in hand the revision of French official scripts and in consequence, the clerks in the offices of state were instructed to abandon the old Gothic cursives and to confine themselves to the upright Ronde known as *financière*, inclined *bâtarde*, and a running form known as *coulée*.'

Copy books featuring the Italian forms were engraved and widely accepted as the standard for writing. Eventually too, they influenced the typography of that nation.

Morison continues, '. . . French models of calligraphy circulated also in England and Holland; French influence in England being more direct than the Italian, . . .' From the time of Jean Baptiste Colbert's patronage the *bâtarde française* forms have remained the French national script.

The reverse specimen of financière facing is from Bardedor's *Les Escritures financière et Italienne bastarda*, an early copy book. The examples of Bâtarde, Coulée and Ronde are from J. Girault's *Album Graphique*, another copy book produced a hundred years later. There is no great departure from the Barbedor standard.

Also on page 79 is shown part of a catalogue presentation of Thompson Calligraphic, a photo-lettering alphabet based on the historical Bâtarde style of script.

Photo-lettering is a recent development by which letters are photographically projected, letter by letter, from a negative master alphabet plate to compose words and lines of words. The designer may include in his alphabet alternate characters that may naturally occur in hand work. These are chosen by the machine operator much as the letterer himself may vary certain characters to improve word-design structure. (Other examples of photo-lettering may be seen on page 124.)

The decrees of the Parlement de Paris of 14 July and 26 February, 1633 authorize the writing masters to teach pure forms of lettres françaises and italiennes as drawn up by Barbedor and Ph: Lebe respectively. Cf. Vallain, Lettres a Mr. De . . . Sur l'Art d'Ecrire. (Paris 1760)

financière dans sa naïfueté.

...nce ! ...es autres Escritures françoises

& ...vitres selon les diverses occurrance...

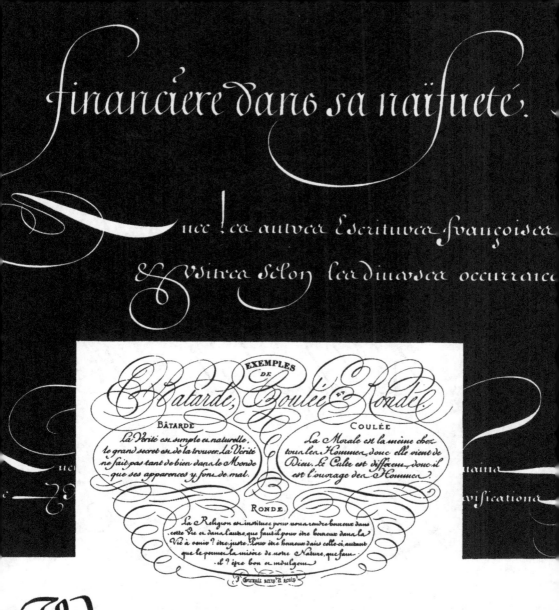

EXEMPLES DE
Batarde, Coulée ET Rondé.

BÂTARDE
La Vérité est simple et naturelle,
le grand secret est de la trouver. La Vérité
ne fait pas tant de bien dans le Monde
que ses apparences y font de mal.

COULÉE
La Morale est la même chez
tous les Hommes, donc elle vient de
Dieu. Le Culte est different, donc il
est l'ouvrage des Hommes.

RONDE
La Religion est instituee pour nous rendre heureux dans
cette Vie et dans l'autre, que faut il pour être heureux dans la
Vie à venir ? être juste. Pour être heureux dans celle-ci, autant
que le permet la misère de notre Nature, que faut-
il ? être bon et indulgent.

WHEN, in the Course of human Events, it becomes necessary for one People to
dissolve the Political Bands which have connected them with another, and to assume
among the Powers of the Earth, the separate and equal Station to which the Laws of

Aaa Bbb

Eef Fff Gg

Kkk Lll Mm

Qqu Rrr Sss

Ww Xx

Ccc Ddd

Hhh Iii Jjj

Nn Oo Ppp

Tt Uu Vvv

Yyy Zz

Nous nous persuadons souvent d'aimer les gens plus puissans que nous, et néanmoins c'est l'intérêt qui produit notre amitié; nous espérons toujours en recevoir une faveur.

Il y a du mérite sans élévation mais il n'y a point 123345 d'élévation sans quelque mérite. 567890.

Un Valet se présentant pour servir un Militaire, celui-ci lui Demanda un Répondant: comment l'entendez-vous, répliqua le valet; C'est moi qui en demande pour mes gages

Girault script. & sculp.

From *Album Graphique*—J. Girault, 1867.

From *Dictionnaire de Chiffres et Lettres de Pouget*, 1767.

Boom in

Beauty

Coulée.

Ronde.

for Digestion's sake

... Smoke Camels

Ronde.

19th Century French Painting

Bâtarde.

83

from Paris Office :

Suddenly Petals are Everywhere

Look magazine

More people smoke Camels than ever before!

R. J. Reynolds.

Evening Star

Woman's Home magazine.

The single weight alphabet is the youngest offspring of the script family. It has evolved from the last generation's unshaded penmanship. It is decidedly of the feminine gender, and it shows a close affinity to the cosmetic and fashion trade. In structure it is based partly on Round Hand and partly on Bâtarde and Coulée forms. Its amount of freedom is established in part by the copy with which one is working. In the use of this letter, a close guard must be kept on its readability. Open round forms must be maintained.

from Kathleen Mary Quinn

84

Quinlan Facial Tissues

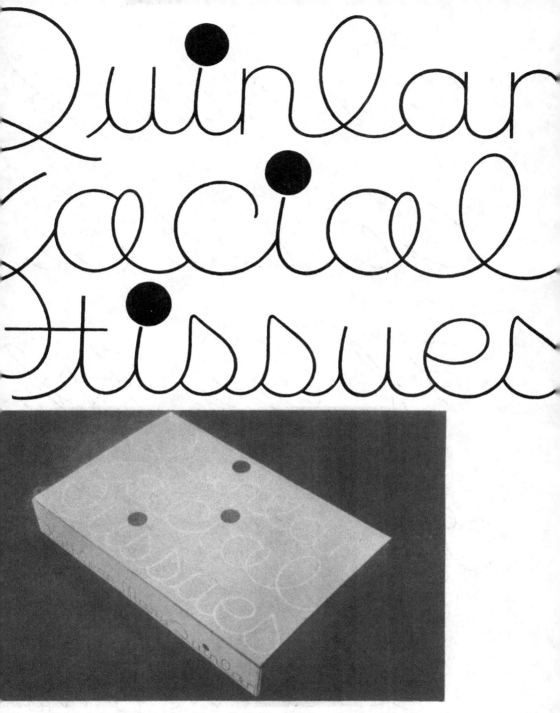

An adaptation of the single weight letter adapted from a Ronde form, applied to a tissue box design. Executed for Kathleen Mary Quinlan. Background Nile green, lettering in silver, dots black.

Photo: Arthur O'Neill.

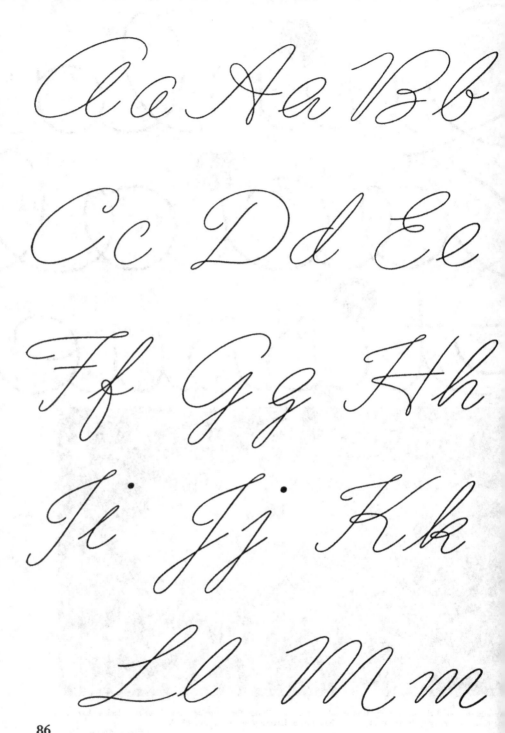

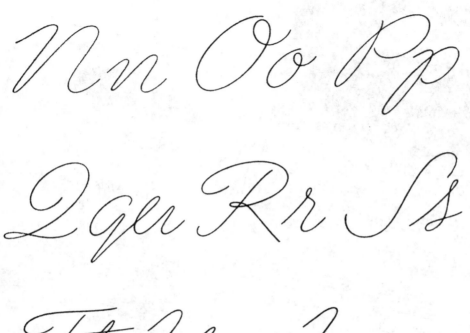

It may be observed that the structural form of this letter is virtually that of the Round Hand. A good example of transitional style in the direction of decadence. It is best used only for short captions. In a small size its weakness becomes much too apparent.

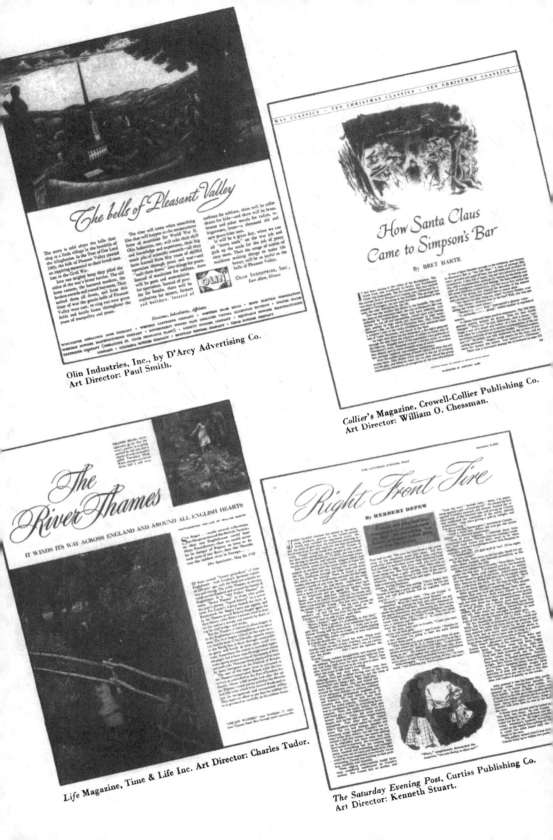

Olin Industries, Inc., by D'Arcy Advertising Co.
Art Director: Paul Smith.

Collier's Magazine, Crowell-Collier Publishing Co.
Art Director: William O. Chessman.

Life Magazine, Time & Life Inc. Art Director: Charles Tudor.

The Saturday Evening Post, Curtiss Publishing Co.
Art Director: Kenneth Stuart.

FREE STYLE

This rapid, informal script is drawn on an exaggerated slant, and based on a free style of handwriting.

The first sketches for this alphabet were written with a soft pen, and then re-drawn and carefully inked.

Particular study is required in the matter of joining the letters together.

Although I have shown methods of joining many of the letter combinations, others will present themselves.

Success in the use of this letter depends upon its readability and smooth flow. It is by all means to appear as if it were written quickly. If any little nicety of design conflicts with its legibility, eliminate it.

The small round letters drawn slightly above and below the base line add greatly to the free appearance of this letter.

Handwriting specimen, C. F. Yale—Eastman Business University, 1875.

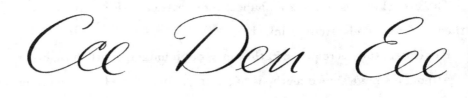

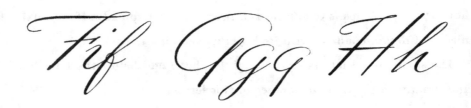

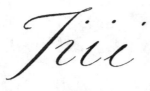

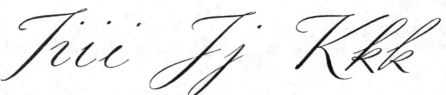

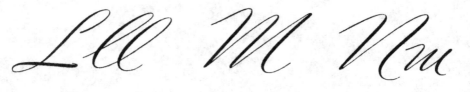

Ooo Ppp Qu

Rrr Ssss st

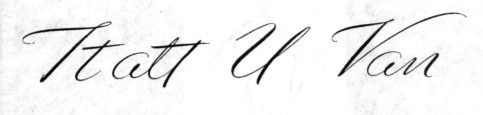
Ttatt U Van

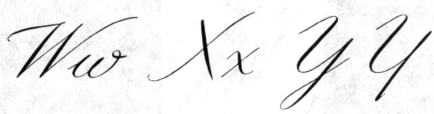
Ww Xx YY

Z of qu ld dy

from

R.J.R. Reynolds Tobacco Company

The obligation of a man

Right Front Tire

By: HERBERT DEPEW

The Last of the Curvilians

Is this the year to change your type?

How do you know you aren't beautiful?

1. R. J. Reynolds. 2. Waldorf-Astoria. 3. *The Saturday Evening Post.* 4. W. & J. Sloane. 5-6. *Woman's Home Companion.*

AN INTRODUCTION TO
LAYOUT

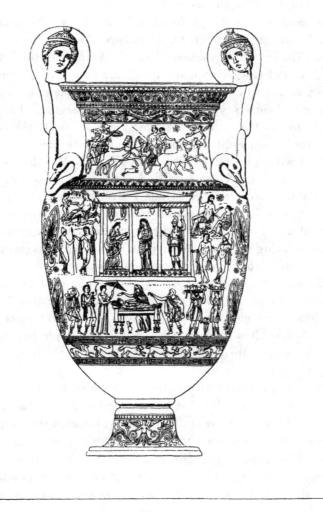

Vase from Recueil des Monuments—Gorginio, Naples 1845

(New York Public Library).

AN INTRODUCTION TO LAYOUT

To create a design, the student must depend upon his own trained sense of balance, which can only be developed by a study of existing good forms. There is a wealth of material to work from. Nature, the Library and the Art Museum are the student's best sources of inspiration. He should not imitate contemporary successes.

In the examples of design he absorbs in study, and trains himself to analyse, found in Architecture, Furniture, Pottery or Decoration that have been thoughtfully planned through the centuries, these underlying principles will obviously appear; relief from monotony, a variety of areas, a planned division of masses, proportion and poise and rhythm.

There are theorists who contend that all design is based on mathematical formulæ. Formulæ best serve to add weight to the proof of a good design after it is completed, but rule and rote can be of little use in application without a natural sense of rhythm. Rhythm is as important in graphic art as it is in music. W. A. Dwiggins in his very enlightening work, *Layout in Advertising*,* which I strongly urge the student to read, writes, 'Rhythm is the thing that puts life into a design—keeps it from being dead and mechanical. In graphic space design it may be crudely defined as a living ratio or size relation among various parts. An instance is the series of ratios of areas in the well-proportioned margins of a book. The rightness or well proportion is all in your eye, but it is a definite and positive thing nevertheless . . . The simplest example of rhythm is a pulse beat, or a uniform wave motion, or a picket fence.'

Mr. Dwiggins then explains that from this simple beginning you may progress by steps, until you arrive at groups of rhythmic relations that are very complex.

A diagram of a candlestick is shown in which no two spaces are equal, and he continues, '. . . but they are sorted and distributed according to a sense of rhythm that has for its element of charm the same quality that makes a wave motion more interesting than a straight line.'

I have elaborated on Mr. Dwiggins' example by diagramming the vase shown on page 95. It will be observed that no two spaces either horizontal or vertical measure the same, a perfect example of variety of areas or

* *Layout in Advertising*, W. A. Dwiggins, Harper and Brothers, 1928.

96

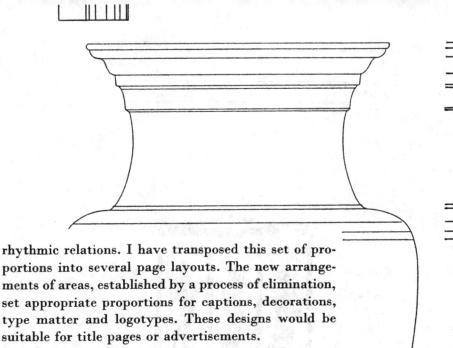

rhythmic relations. I have transposed this set of pro-
portions into several page layouts. The new arrange-
ments of areas, established by a process of elimination,
set appropriate proportions for captions, decorations,
type matter and logotypes. These designs would be
suitable for title pages or advertisements.

As a problem in application, try your skill at con-
verting the design of a Chippendale mirror into a letter
head or package design.

'To become adept at the game of transposition, of
equivalences, it is necessary first to absorb oneself in

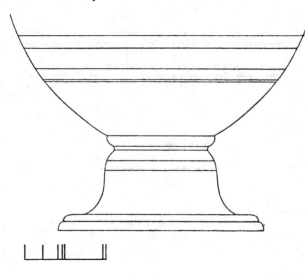

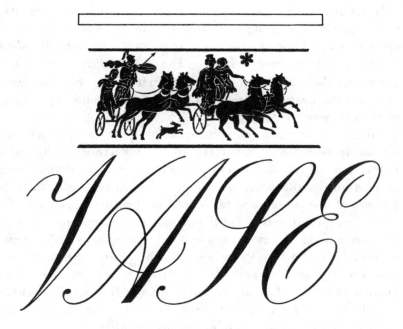

VASE

the chosen model and then, as it were, forget it or come back to it only with a certain reaction, leaving the imagination free to recreate it as if it had never existed outside one's own consciousness. For practice, one might amuse oneself by seeking in every ancient work the feature

which a dexterous subterfuge might convert into a startling piece
modernism.'*

In laying out a page it is a good plan to label the elements that a
to be included according to their importance. Appropriate the domina
areas of your design to the most important and the subordinate are
to the supplementary material. The subordinate areas must not
obtrusive; they should support and be in harmony with the principal ar
or areas, the lesser ones grouped or placed according to the importan
of their messages.

Notice how the areas of white space between the units in these desig
are as necessary and important to the structure of the pages as t
proportions of the drawn and printed material. In design, each page
as pleasing as the vase, its source. They were successfully convert
because of a sense of good taste used in their arrangements.

The accepted formula for the proportions of margins of a book pa
is: inner margin narrowest, top and outer margin wider by steps, and t
bottom area of white space widest. There are other ways as pleasi
however, try for instance: the top space widest, and the space at t
bottom less than that of the outer margin. Let's call attention to t
novelty of this plan by introducing a decoration in the largest spa
not with the thought to subdue but to accent it.

Paul Smith, Art Director, Kenyon & Eckhardt, the most creative d
signer of advertising matter it has been my good fortune to know and wo
with, says, 'An advertising layout is a " machine " for capturing a reade
eye and directing his attention to a sales message in an orderly mann
Often it has the additional task of providing by its general impressi
an appropriate mood or setting for the message. Like any other we
designed machine it should be no more complex than absolutely necessa
—it should have no meaningless forms, no useless parts. It is amazi
how much easier the designer's problem becomes when this view is take

'Often a mechanical limitation becomes a source of inspiration inste
of a headache to the designer if he approaches the problem logically. T
printing process to be used, the audience to be reached, the paper and ty

* A. Tolmer, *Mise en Page*, The Studio, London & New Yo

100

which must be used, all are just as important as the message itself in determining an advertisement's graphic form.

'The most important single factor in successful design is a frank acceptance of the limitations of the material. Type is type, not neatly ruled lines on the layout. An overprinting stunt can be a simple and easily printed graphic device—or it can be a nightmare to the engraver, depending on the designer.* Learn to think in terms of the final product—in terms of type, engraving, printing processes rather than clever pencil marks on paper. Then you will begin to be a designer and not just a layout man.'

* As Theodor Leschetizsky, a great teacher of piano technique, once said, 'That which is not easy is not correct.'

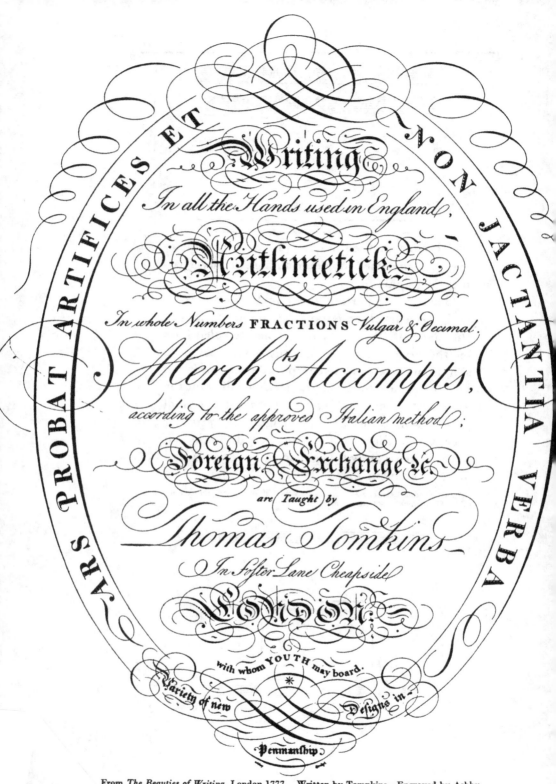

ARS PROBAT ARTIFICES ET NON JACTANTIA VERBA

Writing

In all the Hands used in England,

Arithmetick

In whole Numbers FRACTIONS Vulgar & Decimal,

Merch.ts Accompts,

according to the approved Italian method;

Foreign Exchange &c

are Taught by

Thomas Tomkins

In Foster Lane Cheapside

LONDON

with whom YOUTH may board.

Variety of new

Designs in

Penmanship

From *The Beauties of Writing*, London 1777. Written by Tompkins—Engraved by Ashby.

Merry Christmas
from Magda and Jack Tarleton

Two modern interpretations of the formal engraving on the left. The greeting card executed for John V. Tarleton. The dedication design for Alfred Knopf's *Made in France*. The figure of the child drawn by Walter Stewart.

Dedicated to Sophie Reagan

103

This map design, drawn for the Henry Clay and Bock & Co. Ltd., is very dependent on decorative treatment. It was used as end paper in a booklet produced for the advertisement of La Corona cigars. The flourishes that decorate the names of the oceans, and the title, contribute greatly to the success of the purpose of the map. It was printed this size in a light tobacco colour.

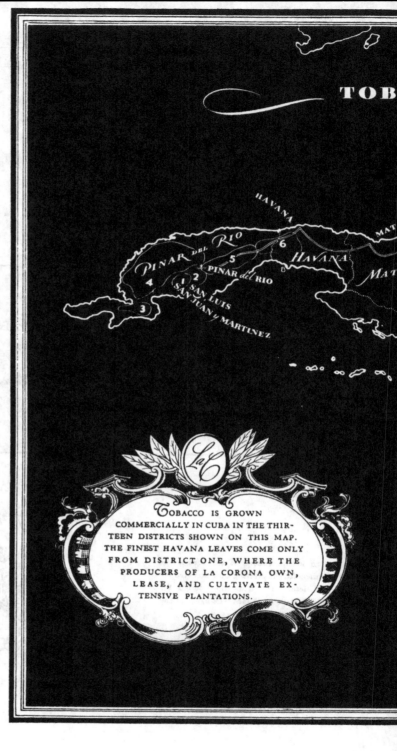

TOBACCO IS GROWN COMMERCIALLY IN CUBA IN THE THIRTEEN DISTRICTS SHOWN ON THIS MAP. THE FINEST HAVANA LEAVES COME ONLY FROM DISTRICT ONE, WHERE THE PRODUCERS OF LA CORONA OWN, LEASE, AND CULTIVATE EXTENSIVE PLANTATIONS.

104

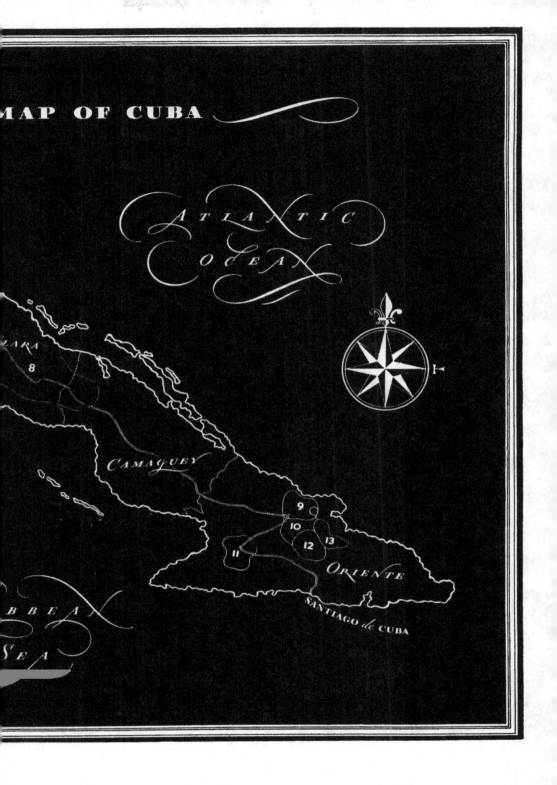

Comprehensive dummy packages: J. Walter Thompson Company.

The above design was copied in the course of study from a small engraving by Ashby in *The Beauties of Writing*, executed by pen, retaining an engraved character. The package designs, opposite page, and the palette decoration below, drawn for *Reader's Digest* magazine, show similar styling applied to actual commissions.

The

PACKAGE DESIGN is enriched in the case of a tobacco product by following the tradition of tobacco packaging. A fine product requires a suitable presentation. Such a problem suggests: good design, fine engraving or lithography, embossing, natural wood, tasteful colour. The component elements in the composition of these cigarette package designs were developed with this tradition prominently in mind.

Caption: *The Saturday Evening Post.*
Cartouche: Wine Growers of California.
Initial: N. W. Ayer & Son.
Packages and Seals: Peter Jackson Ltd. and P. Lorillard Company.

ALL YOU NEED TO KNOW to Serve Wine

Old Gold

CIGARETTES

Made for your smoking enjoyment from choice imported and domestic tobaccos expertly blended.

P. Lorillard Company
Established 1760

108

Promise

Made by Lorillard, a famous name in tobacco for nearly 200 years

OLD GOLD
CIGARETTES
Pocket Forties

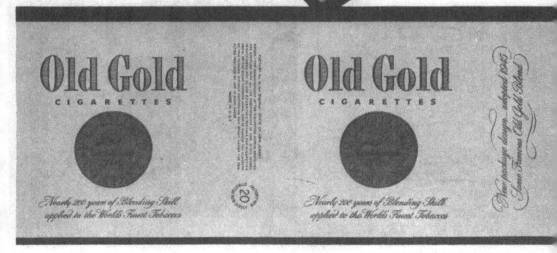

Nearly 200 years of Blending Skill applied to the World's Finest Tobaccos

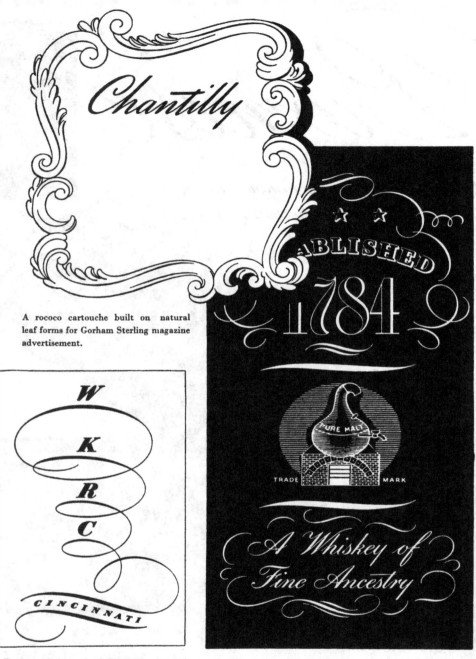

Chantilly

A rococo cartouche built on natural leaf forms for Gorham Sterling magazine advertisement.

ABLISHED
1784

PURE MALT
TRADE MARK

A Whiskey of Fine Ancestry

Trade mark design for Columbia Broadcasting System Inc. It is dependent on the placing of waved lines and spiral flourishes.

Brochure cover for Bushmills. Numerals and flourishes in green, stars in gold. Notice how the strong waved lines draw attention to old illustration of pot still.

110

FROM

THE

LIBRARY

OF

Albert and Edna

DORNE

Book plate design for Albert and Edna Dorne.

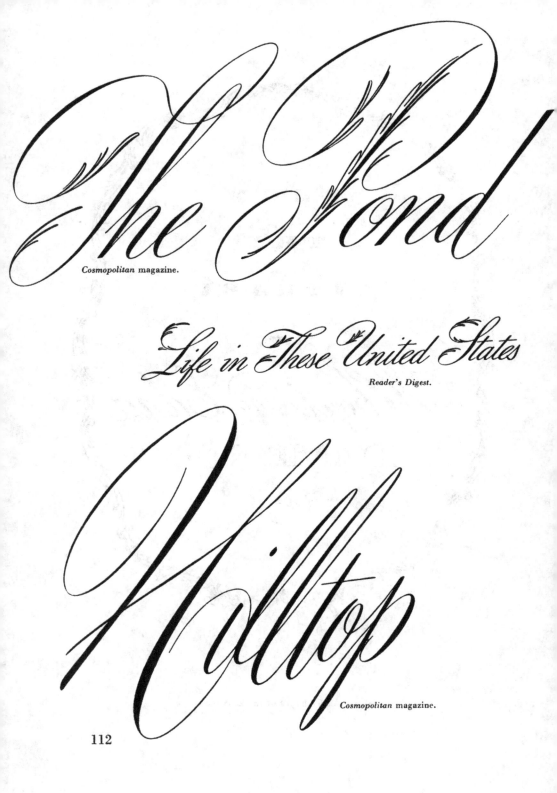

The Pond

Cosmopolitan magazine.

Life in These United States

Reader's Digest.

Hilltop

Cosmopolitan magazine.

Label:
Private Library.

Stamping Die: Testimonial:
Crowell-Colliers Pub. Co.

Trade Mark: New York Life Insurance Co.

FROM
THE RECORD LIBRARY OF

N.H.W.

NO.

He could give up the house and the way they lived, he knew, but how could he possibly ask the wife he loved to start all over again at the beginning?

113

Ifffuffenkrabgeecy Ogze y josqui

Camouflflightoecrerstonyewivot Is

A ijeeoffcyenkrdbgyanquxtizzenzzig-

Apimyg!?/ffiff F Flo I-b.;; ""§

gl (O) 1243569807 () D E E

nya a pimy l l e e r ou ghtosto ivot I

Personality Backgrounds

The River Thames

DESIGN PROJECT: *Life* Magazine, photo-lettering script. Build-up to typographic colour was tested in magazine's format, developed in word structure for character count and style.

The master alphabets with many alternate characters were drawn for typographic colour, grading from 24 point to 120 point, and charted for practical use by the magazine's writers and layout men.

A Fancy Summer

PREVIEW OF HOT-WEATHER STYLES SHOWS THE FORMAL. FOREIGN LC

Margaret Truman

American Look

Baroque Elegance

Patrice Munsel

Nina Foch

Fanciful Moder

The Quick Brown Fox Jumps Over The Lazy Do

Collier's wishes you

a Merry Christmas and

a Happy New Year

HENRY LA COSSITT · *Editor*

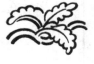

Book Jacket and Binding Design, *Random House*.
Typographic Initial Decorations, *Collier's*.
Camels Cigarettes, Christmas Carton.

Merry Christmas

116

Albert Schweitzer

T H E
CASUAL DRAPE
BY Stein Bloch

FIRST CLASS

The Little Cosmetician

R de

Rosemarie de Paris

The Gunsmith and the Lady

Look Magazine: Article Heading.
Logotype: Stein Bloch.
Personal Mailing Stamp.
Trade Mark and Logotype. Rosemarie de Paris.
Catalogue: The Little Cosmetician.
Advertising Headline: Olin Industries.

COMMERCIAL HANDWRITING

It is possible to obtain with this type of work a flair or spirit in keeping with an informal style of illustration, as well as the most realistic photography. This cannot always be accomplished with the standard formal styles of script.

During the last several years this method of featuring caption copy has been much in vogue. It lends a personal testimony aspect to any type of advertisement.

Form the letter directly with the least effort, spontaneously. Retouch only for the sake of legibility. Many of the captions shown here were very rapidly executed, both with pen and brush.

Technically these styles are neither writing nor lettering, but dependent for form and colour on both. By this I mean, that it is almost impossible to write any large amount of copy to fit a planned space in the layout, properly spaced and of even colour. Thus it invariably requires working over and respacing. Much time may be wasted in attempting to letter a free style. Therefore, it is more practical to write and correct.

In my experience I have found this the best method: write the copy (with brush or pen, as desired) many times in Indian ink, to conform to a preconceived style on a thin or bond paper. Choose the better parts and cut them out. Correct the spacing during remounting on another thicker or firmer surface.

One may now work over the entire caption, strengthening the letters in some places and thinning them in others until the exact amount of finish or freedom desirable for reproduction is attained.

Practice in this field will prove of immeasurable benefit in appreciating the formation of formal letters.

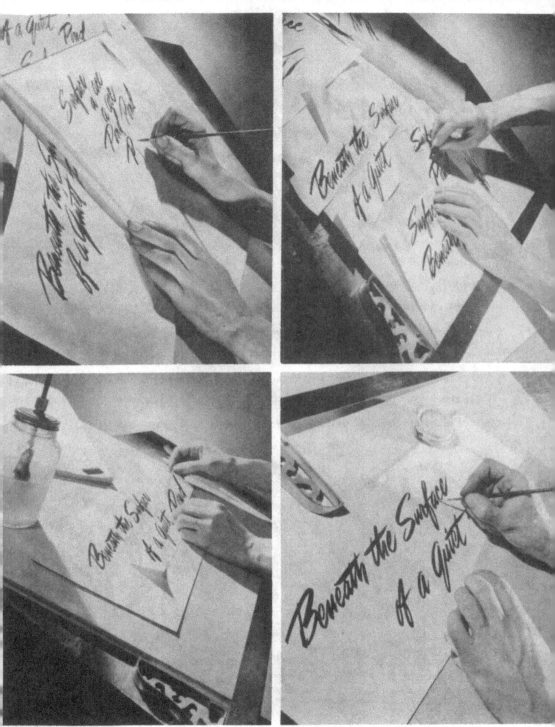

You're So Smart to Smoke

Winsor & Newton No.
Series 7
Sable Hair No. 5

The captions on these two pages were first written quickly and freely with the largest brush possible for the size in which I worked, in waterproof black ink. The best result, in each case, from several versions, was then slightly worked over, first with the same brush and then with a smaller one, in ink. A certain amount of cutting, balancing and rearranging was then necessary. Further retouching is usually needed at this stage. Some use of a fine pen may prove expedient.

Final steps entailed cleaning out excessive blackness from such letters as m, n and

Paris Looks to Her Laurels

DRAWING BY JOHN C. PELLEW

Judith Garden

Winsor & Newton No. 1
Series 7 Sable Hair No. 2

More Camels

"Lovelier now than a month ago"

u, where clotting usually occurs. Also opening loops in closed letters, such as e, o and s. This is accomplished with a smaller sized brush and water-colour white.

Work at all times for quick readability. Make all letters legible by themselves, or at least readable in association with letters immediately following. In first writing words, effect all breaks or disconnections on the syllable. In all cases when readability is attained—call it done. Too much repairing will lose the freedom of the style. If possible try to correct the letters on one side of the black line only, leaving the natural brushy character, as it is, on the other.

Joseph Gillott
No. 170

Joseph Gillott
No. 290

The flowers that bloom in the Fall

Black and white striped stiffened chiffon bustles behind.

Lanvin – Hattie Carnegie

Gordon-George Patent Speedball
Hunt Pen Co. A-2.

Anne Rockefeller

R. J. Reynolds Tobacco Co.

Grumbacher Glyder
Square Dome No. 6 (6/64").

Spencerian Art Series
Extra fine point No. 97.

"—for Digestion's Sake — Smoke Camels!"

Costlier Tobacco!

Grumbacher Manuscript No. 7 (7/64").

Gordon-George Patent Speedball Hunt Pen Co. B-3.

Get a Lift with a Camel!

Grumbacher Glyder Full Disc No. 2 (2/32").

The Rainbow Room

R. J. Reynolds Tobacco Co.

123

How Santa Claus Came to Simpson's Bar

A Rich Glow at Christmas

Christmas Trees The Little Match Girl

The colorful Canopy
of the
Strolling Players

—

Penscript

~

A delicate and legible

Script Letter

designed for the Photo-Lettering
process of production

Examples of photo-lettering designs: Thompson Calligraphic, Thompson Scribe, Thompson Penscript.

Thompson Quillscript

A B C D E F G
H I J K L M N O P Q R
S T U V W X Y Z
-[A A E F H J K L M N T V W]-
$1234567890£
(& * . , - " " ' ' : ; ! ? ~ &)
~ abcdeffghhijklmnopqrstuvwxyz ~

Baltimore Script

A B C D E F G H
I J K L M N O P Q R S
T U V W X Y Z
$ 1 2 3 4 5 6 7 8 9 0
* [f f s y - 0 V W]
abcdefghijklmnopqrstuvwxyz
(. , - " " ' : ; ! ?)

Foundry Typeface Designs: Thompson Quillscript, 24 pt.; American Typefounders
Baltimore Script, 24 pt.; Baltimore Type & Comp. Corp.

abcdefg

ABCDabcef

The Quick B

ABCDEF

ROUND BRUSH CUT SQUARE

San Francisco eats well, has fun after dark

Old Gold

More people smoke Camels than ever before!

Bat

ROUND

BALL POINT

Rigger brush

SQUARE STUB POINT FOR CARTOONS

Nearly 200 years of Blending Skill
applied to the World's Finest Tobaccos

TOOLS STYLE LETTERS

In order to draw a particular style of letter, you must know and choose the tool that most closely approximates the weight of the letter you wish to execute; don't try to make a tool do work that is outside its natural, physical limitations. When the above styles are drawn it will be found that a round tool will make an unvarying weight and that a flat tool will execute thick and thin strokes. Remember, the type of tool will 'style' the letter when it is used to draw the strokes directly—if you recognise the characteristics and limitations of the tool as a writing instrument.

In finishing letters for reproduction, it is advisable to clean the edges and serifs of letters somewhat with a finer pen or brush rather than try to draw perfect letters directly with the large tool that forms them. The Camel caption above is an example of this way of working. The free letters were written quickly with a round brush with the concentration put on producing a pleasing word design; then rough edges and bad weights were corrected with a fine pen. In styles such as this, where a certain freeness is desirable, much of the work's character may be lost if the lettering is traced down to another working surface.

Whichever method is used, built up or drawn letters may only be executed intelligently when one fully appreciates the fact that a certain kind of tool was used directly to form the progenitors of all existing letter styles—the class Roman capitals.

In employing finer tools to build up or finish a desired letter form, do not favour one part of the design at the expense of some other part of it. Remember to study the relation of the letter within the alphabet and the underlying characteristics of all the letters. For, only by a pleasing formation of word patterns can lettering fulfil its function to the reader.

126

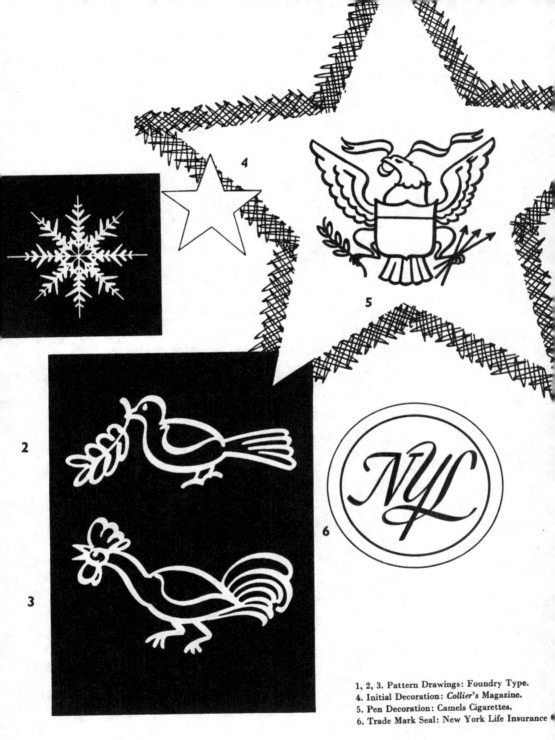

1, 2, 3. Pattern Drawings: Foundry Type.
4. Initial Decoration: *Collier's* Magazine.
5. Pen Decoration: Camels Cigarettes.
6. Trade Mark Seal: New York Life Insurance